Painting Still Lifes

IN OILS

Library of Congress Catalog Card No. 95-37550

International Standard Book No. 0-8120-9402-6

Library of Congress Cataloging-in-Publication Data
Bodegones al oleo. English.
 Painting still lifes in oils / [author, Parramón Ediciones
Editorial Team ; illustrator, Esther Olivé de Puig].
 p. cm. — (Easy painting and drawing)
 ISBN 0-8120-9402-6
 1. Still-life painting—Technique. I. Puig, Esther Olivé de.
 II. Parramón Ediciones. Editorial Team. III. Title. IV. Series.
ND1390.B5613 1996
751.45'435—dc20 95-37550
 CIP

Printed in Spain
6789 9960 987654321

IN OILS

Painting
Still Lifes

BARRON'S

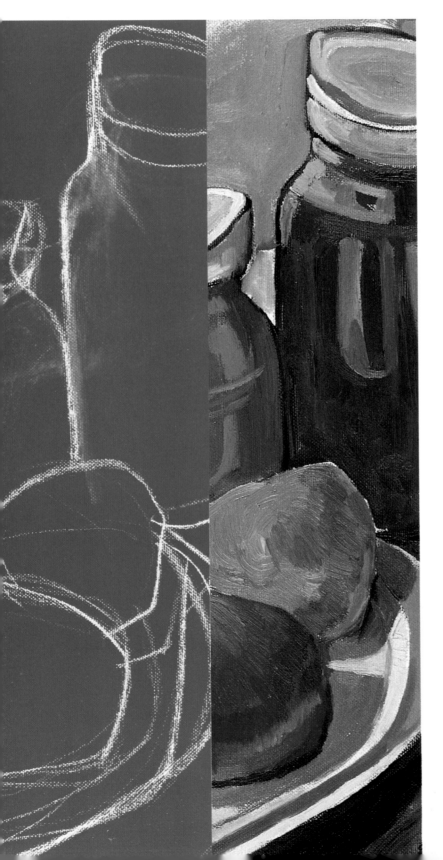

CONTENTS

*T*he still life, such an apparently simple theme, is the subject of this book. One or two household objects are all that is needed to paint a still life, you may be thinking. Nothing could be further from the truth. A wide range of factors must be considered when embarking on a still life, such as the shapes of the objects and their position in the still life setup, the combination of colors, the lighting, the balance of light and shadows, the relationship between light and dark tones, the infinite choice of values and hues of each color, the placing of volumes and masses, the background, the amount of attention given to each of the elements, their movement or rhythm—all of these are essential for creating a good still life painting.

The exercises in this book will show you, the beginner, the basic techniques for learning how to paint still lifes in the most interesting and entertaining way. Here we provide you with the knowledge; the rest depends on your curiosity and tenacity. The key to success is to start with simple themes and gradually increase the complexity of your work.

I wish you every success with this fascinating and satisfying pastime. Within a short time, your efforts will begin to bear fruit.

Jordi Vigué

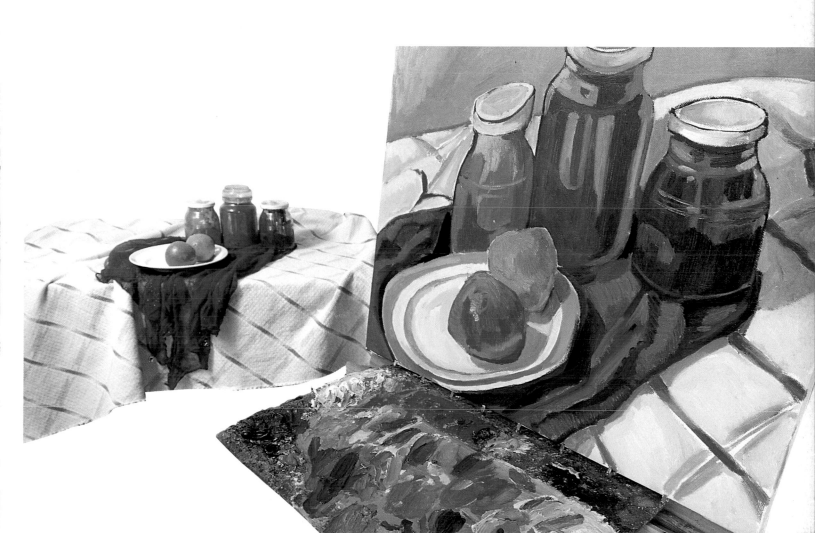

PAINTING IN OILS

Oil paints are basically made up of a mixture of pigment or color with linseed oil, which produces a slippery, slow-drying paste.
The characteristics of oil paint necessitate the use of specific materials and equipment, and influence the way in which an oil painting is developed.

MATERIALS

The basic materials required for oil painting are: an easel; something to paint on, which can be made of canvas, cardboard, wood, etc.; brushes, for applying the paint; a palette or similar object on which we can keep and mix colors; and finally, the oil colors, of which there is a wide variety of brands and qualities.

There are some additional items that are not essential but come in very handy, such as rags and old newspapers for cleaning the brushes and the palette; a palette knife for scraping oil paint off the palette or canvas; a pot or jar containing turpentine for diluting the paint; thin and thick sticks of charcoal for drawing the composition on the canvas; a drawing pad and soft (4B) pencil for drawing the composition; and soap for cleaning the brushes. It is important to organize these to enable us to work comfortably. In this way, we turn our work space into a studio and ourselves into painters—beginners, of course, but promising ones, nevertheless.

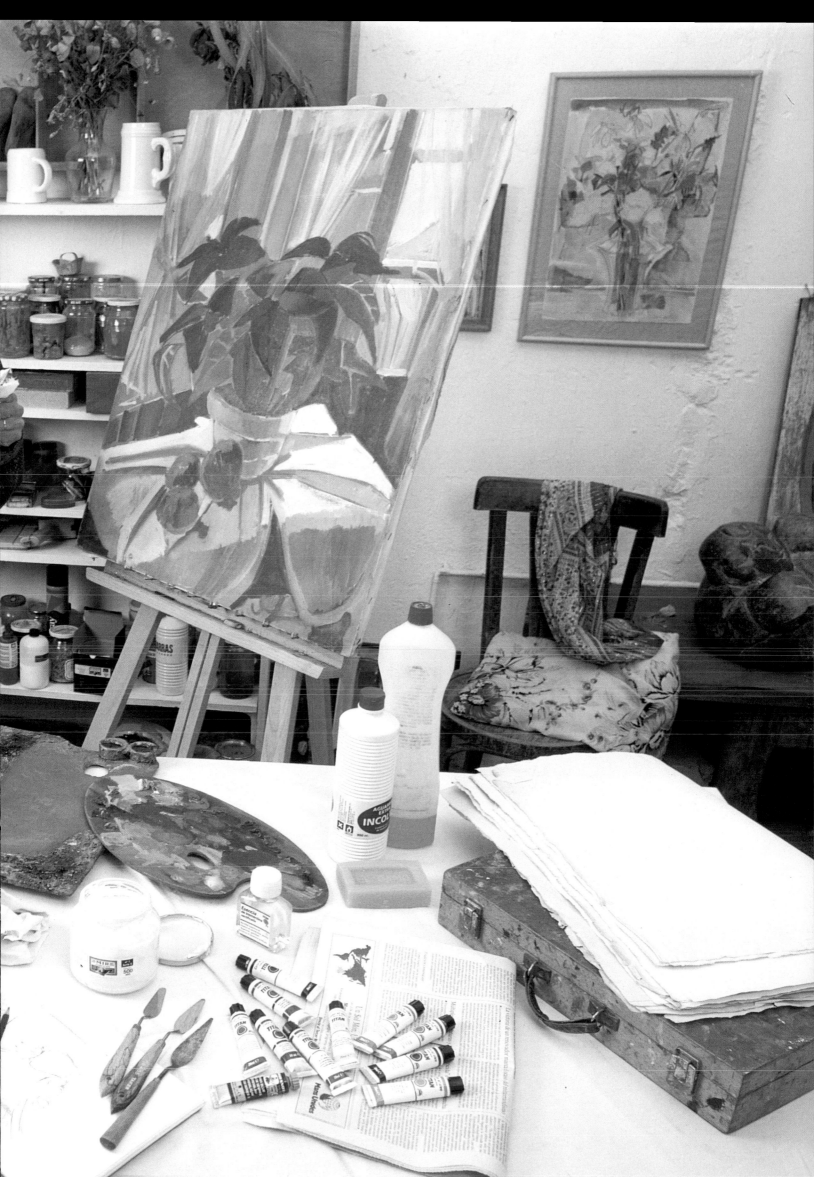

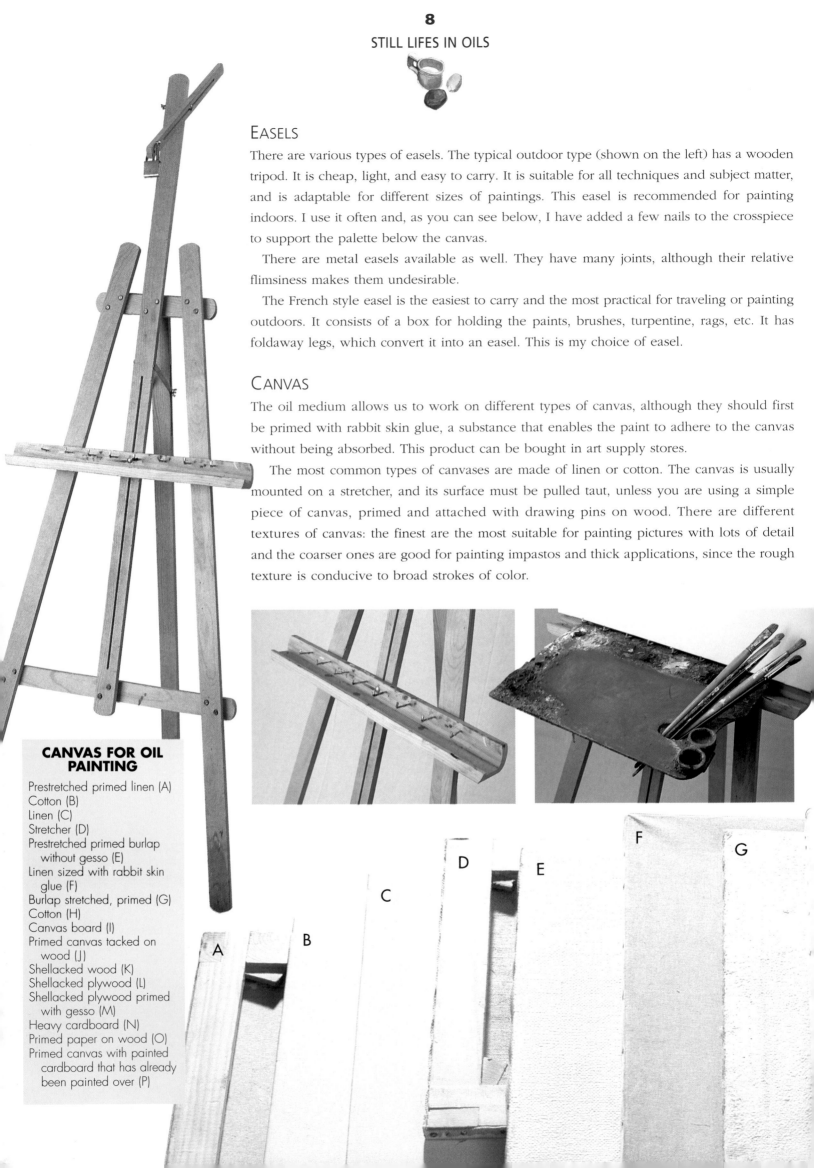

EASELS

There are various types of easels. The typical outdoor type (shown on the left) has a wooden tripod. It is cheap, light, and easy to carry. It is suitable for all techniques and subject matter, and is adaptable for different sizes of paintings. This easel is recommended for painting indoors. I use it often and, as you can see below, I have added a few nails to the crosspiece to support the palette below the canvas.

There are metal easels available as well. They have many joints, although their relative flimsiness makes them undesirable.

The French style easel is the easiest to carry and the most practical for traveling or painting outdoors. It consists of a box for holding the paints, brushes, turpentine, rags, etc. It has foldaway legs, which convert it into an easel. This is my choice of easel.

CANVAS

The oil medium allows us to work on different types of canvas, although they should first be primed with rabbit skin glue, a substance that enables the paint to adhere to the canvas without being absorbed. This product can be bought in art supply stores.

The most common types of canvases are made of linen or cotton. The canvas is usually mounted on a stretcher, and its surface must be pulled taut, unless you are using a simple piece of canvas, primed and attached with drawing pins on wood. There are different textures of canvas: the finest are the most suitable for painting pictures with lots of detail and the coarser ones are good for painting impastos and thick applications, since the rough texture is conducive to broad strokes of color.

CANVAS FOR OIL PAINTING

Prestretched primed linen (A)
Cotton (B)
Linen (C)
Stretcher (D)
Prestretched primed burlap without gesso (E)
Linen sized with rabbit skin glue (F)
Burlap stretched, primed (G)
Cotton (H)
Canvas board (I)
Primed canvas tacked on wood (J)
Shellacked wood (K)
Shellacked plywood (L)
Shellacked plywood primed with gesso (M)
Heavy cardboard (N)
Primed paper on wood (O)
Primed canvas with painted cardboard that has already been painted over (P)

Wood, being porous, has a firmer and more rigid surface than canvas, although it produces a different effect. It should be varnished or shellacked before using.

Paper and cardboard are the cheapest types of painting materials. They produce inconsistent results with oils but are very useful for painting notes or drawing sketches.

In reality linen canvas is the most comfortable to work with but it is also the most expensive. I do not advise the beginner to use it. It is better to leave expensive canvas to the experts.

You may already realize that used canvases can be painted over, as long as you do not want to preserve them. To take advantage of a used canvas, you will first need to cover the previous painting with a color so you do not become confused by it while painting the new picture. If the layer of paint of the previous picture is too thick, it may dull or disfigure the new work, or it might improve it. This is one thing we can never be certain of.

TABLE EASEL

As its name indicates, this easel is designed to be placed on a table or similar object, obliging the artist to work seated. Although some may find this to be a comfortable way to work, it is not preferred because this position is tiring.

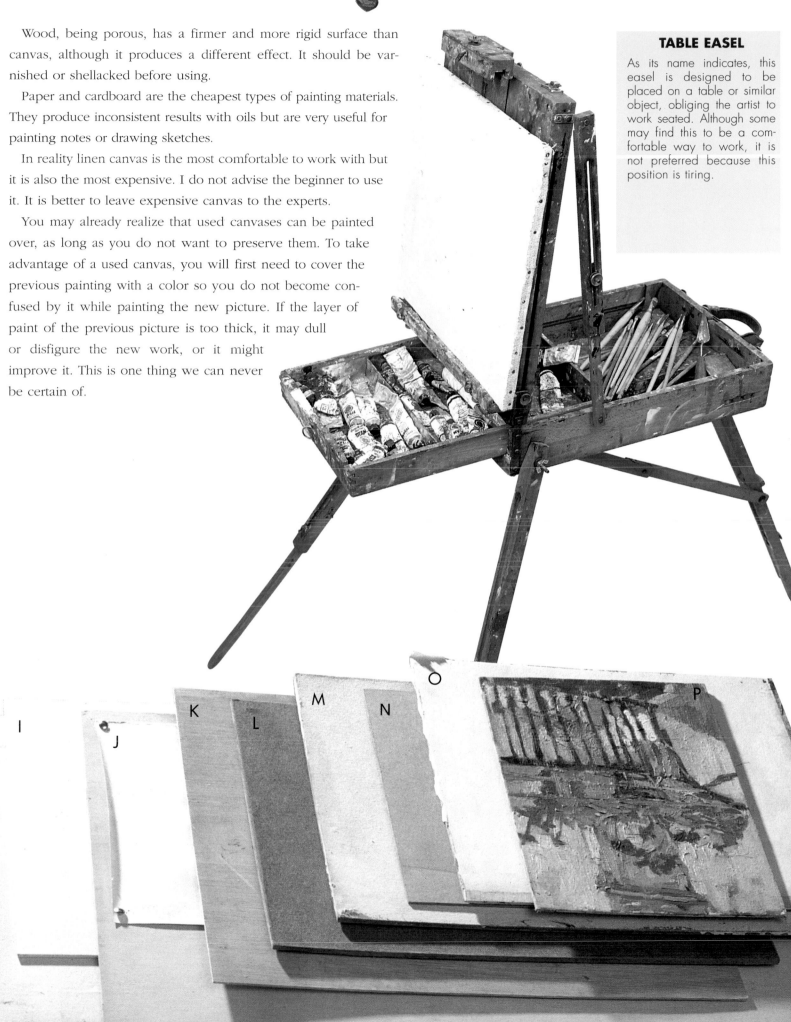

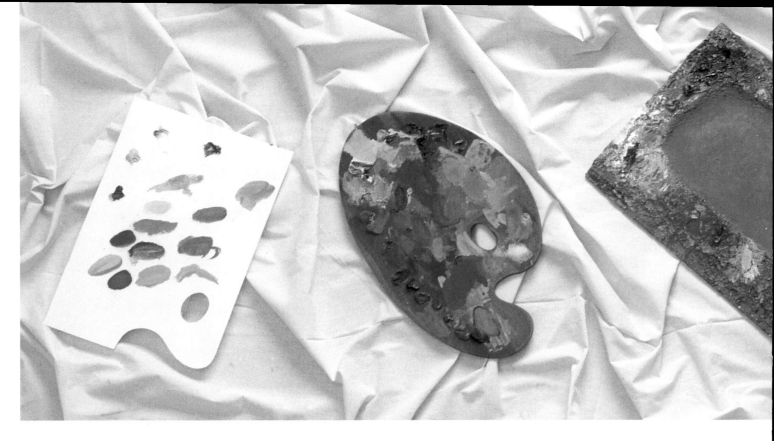

BRUSHES

Brushes come in a wide range of sizes, qualities, and shapes. They are numbered according to size, from the smallest (0) to the largest (24). Fine brushes (0–6, depending on the manufacturer) are suitable for painting details (the pupil of an eye, an outline, etc.), while the larger ones (18–23 are appropriate for filling in backgrounds and large masses of color.

Brushes are made of synthetic fibers, ox hair, sable, or hog bristle. The choice of brush will depend on the quality and texture of the canvas you are going to work on. Fine textured canvas, for instance, requires a harder brush (hog bristle or synthetic fiber). Also, since oil is a pasty product, it requires a resistent, tougher haired brush.

The choice of brush shape is another question: there are round brushes, flat brushes, filberts, and so on. The filbert and the round brush are excellent for painting thick or thin strokes and details. Flat brushes are basically used for covering large areas and color masses. You can also use the thicker side of the brush to obtain different effects.

We recommend that beginners have a set of different sized hog bristle brushes.

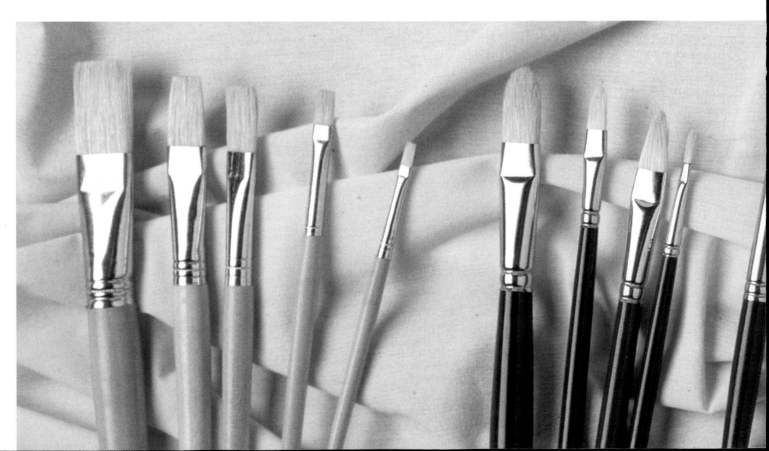

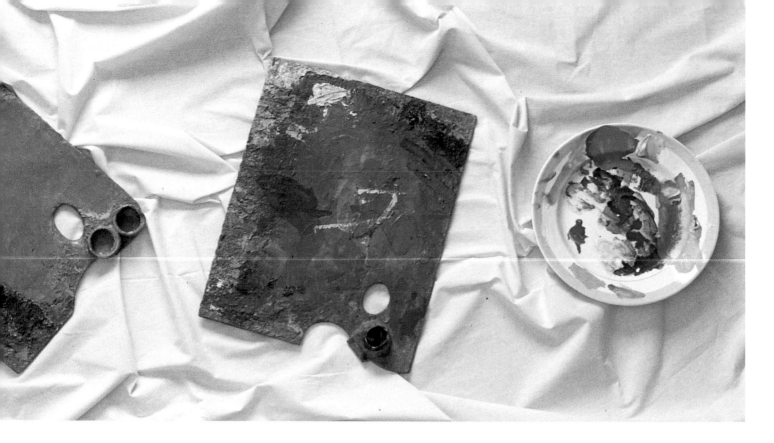

THE PALETTE

A palette is indispensable for holding the paint and, more important, creating mixes and combinations with which you can obtain the colors and tones needed for each part of your painting.

There are palettes of various shapes and sizes. The round palette is especially useful for those people who prefer to hold it in one hand; they are normally made of plastic, which is easy to clean, or wood, in which case an application of varnish is required before using it for the first time to make it impermeable.

The colors should be placed around the edge of the palette. Although there is a specified order to arrange your colors, you can place them in any order you wish, as long as they are easily accessible when you begin to paint. Nonetheless, try to always maintain the same order of distribution.

The center of your palette should be reserved for mixing color. Once the colors have been placed on the palette, they should never be removed unless they are completely dry and, therefore, are of no further use to you.

The palette should only be cleaned when the work is finished or when there is no longer any space for mixing new colors and values.

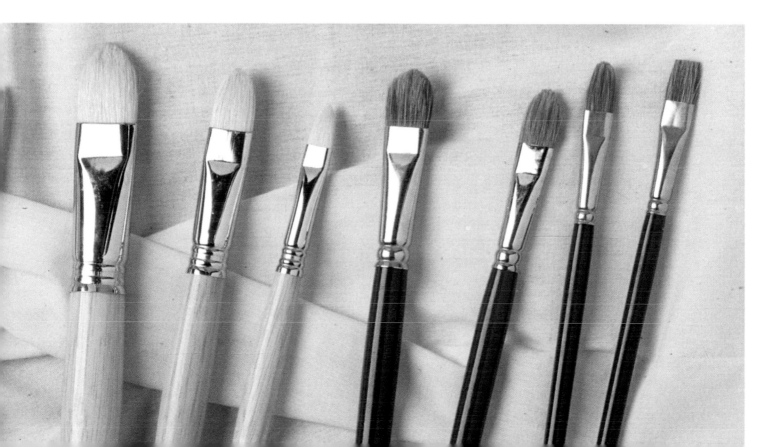

OIL PAINTS

*O*il paints that are sold in stores come in aluminum tubes, which are very practical for keeping in a box, or in tins for those painters who require abundant quantities for covering large areas. There are many different brands, which vary in price and quality.

BASIC ADVICE ABOUT OIL COLORS

One important piece of advice is that beginners should start by using only primary colors: yellow, red, and blue. With these colors on your palette, you can learn to mix secondary and complementary colors, as well as a wide variety of neutral tones.

With practice you will soon be able to mix any color using only the three primary colors. At the bottom of these pages you can see a range of colors: 1. white; 2. cadmium yellow lemon; 3. cadmium yellow medium; 4. cadmium orange; 5. cadmium red light; 6. cadmium red medium; 7. cadmium red deep; 8. permanent rose; 9. alizarin crimson; 10. mauve; 11. ultramarine light;

12. ultramarine deep; 13. Prussian blue; 14. cerulean blue; 15. pale green; 16. dark green; 17. ivory black; 18. burnt umber; 19. burnt sienna; 20. yellow ochre.

Even though it is not essential to have all these colors, as you gradually master your palette you will be able to add some of the colors we have mentioned, or even all of them, to obtain an infinite number of tones. Thus, a touch of dark green added to cadmium yellow lemon produces a very different green from that made of dark green mixed with cadmium orange. In this way we can obtain more and more hues, ad infinitum.

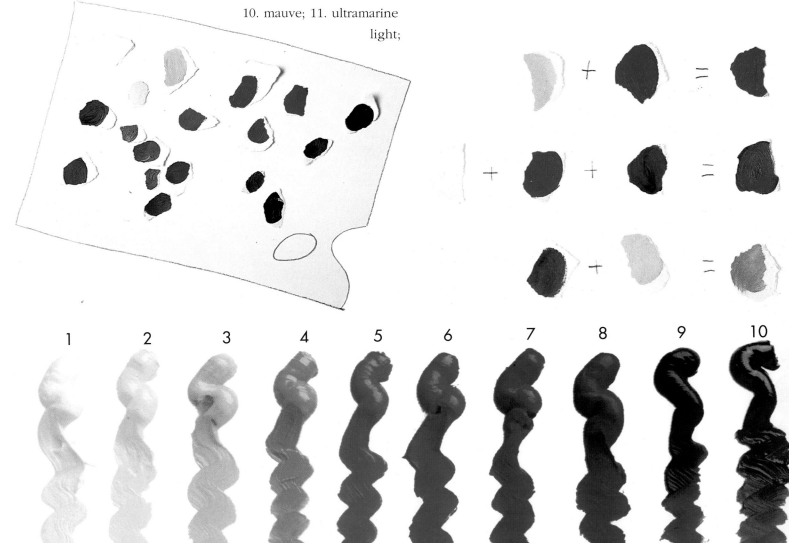

MY PALETTE, MY COLORS

Placing the colors on the palette can be considered
a kind of warm-up exercise. As an example, I will show you
how I prefer to place the different colors on my palette. First
I begin with white, which is placed in the top left-hand
corner, where it is easily accessible, since all the colors will
require a touch of white sooner or later. Next, along the
same top part, I place the yellow lemon, medium yellow,
orange, cadmium red light, medium, and deep, permanent
rose, alizarin crimson, violet, ochre, burnt sienna, burnt
umber, and black. Therefore, the warm colors occupy the
top part of my palette. The lower left-hand side is reserved

WHAT PAINTS SHOULD WE USE?

Cadmium colors are the purest and, therefore, the most expensive. They are also the most brilliant. It is advisable, however, for beginners to start with inexpensive paint. When learning how to mix colors, practice is more important than expensive colors. Later on in this book we will work with better quality paint.

for the cool colors: ultramarine light, ultramarine deep, cobalt blue, dark green, light green. You can see how, when mixing colors together, new ones emerge.

White is used to lighten color, but it is important to remember that white also makes colors lose their brilliance. Black is more difficult to work with, because it can

dirty colors. It can be used to produce colors and very dark
tones, but should not be used to mix grays. With practice
will quickly see how easy it is to obtain a wide variety of
shades.

| 11 | 12 | 13 | 14 | 15 | 16 | 17 | 18 | 19 | 20 |

THE STILL LIFE AS SUBJECT MATTER

*P*ractice is the key to successful oil painting. And we can take advantage of everyday objects to do this, since a single reference point is enough to practice color contrast, value, form, and composition. These elements will enable you to develop your imagination, skill, and creativity.

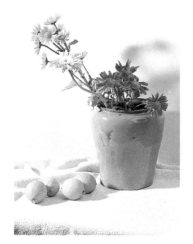

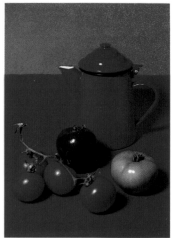

THE STILL LIFE SETUP

A still life is an excellent subject for beginners, because it does not require a great effort; any household objects will do, and the more pleasant they are, the better.

Two or three interesting objects, attractively arranged, are all you need for a still life setup.

When we begin to paint the still life, there are a few basic factors to take into account:

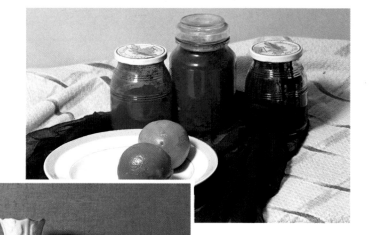

COLOR

You will see the importance of color in the exercises presented in this book as well as in the examples on this page.

These exercises are useful color studies. Each one consists of different values of a single primary color, and its complementary color.

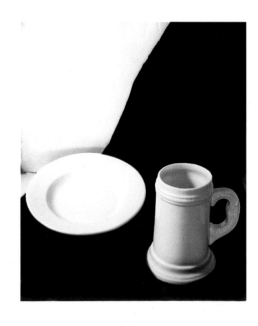

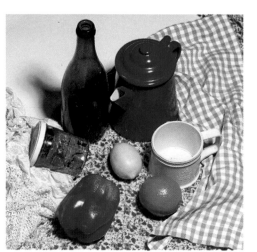

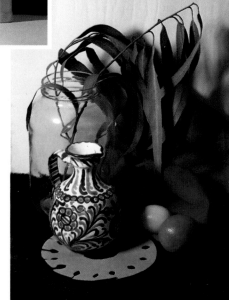

LIGHTING

The combination of light and shadow is an important aspect of color and composition. Compare these two photographs of the same subject (A and B). Both are illuminated by a spotlight on the left, from our point of view. In the first photograph there is a strong contrast of light and shade, but little contrast in the second example. Each of them helps us to learn to compose the distribution of spaces.

COMPOSITION

Notice how in photographs C and D the diagonal lines enable us to see how the picture is balanced. The shadows as well as the rhythm and movement of the flowers and fruit are important factors in developing a good composition.

FORMAT

This is also an important element to take into account. The choice of format depends to a great extent on how we distribute the different objects that make up the still life and the point of view from which we will paint it. It may be frontal (E) or seen from above (F). The inclusion of a horizon line is a useful aid in working out the composition.

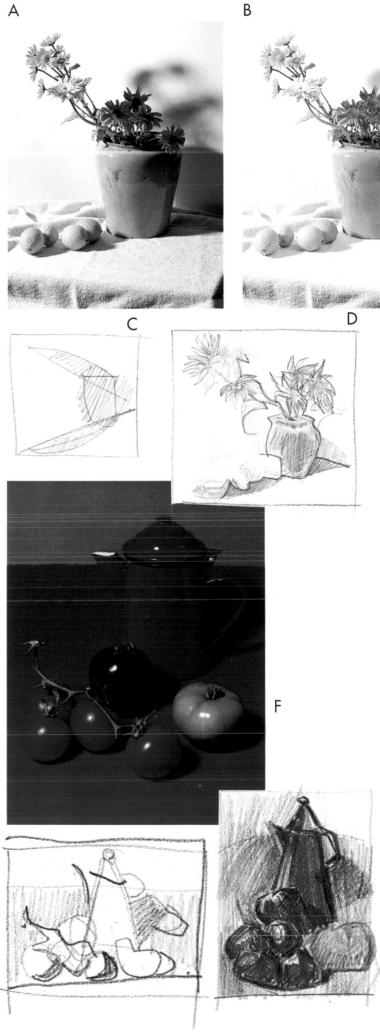

A

B

C

D

F

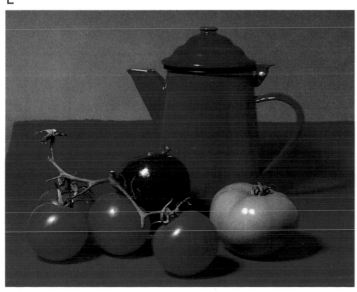

E

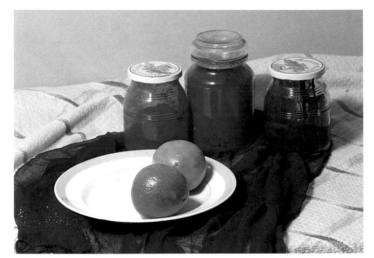

THE DISTRIBUTION OF OBJECTS

The photograph on the left shows a still life in blue. In this exercise, we will see how a single color can provide us with a wealth of tones and hues, which we will then contrast with the white of the plate, which, in turn, will produce a striking contrast with the oranges. There is also a contrast of values, dark against light and light against dark, forming an angle with the apex towards the upper right-hand part of the composition. This is a good example of how we can balance a composition by careful placement of the objects.

COMBINING THE ELEMENTS

The photograph on the right is an example of how the color, rhythm, and general composition create a harmonious ensemble. The primary and complementary colors maintain a perfect balance. The outline of the objects seen from an elevated point of view forms a star that requires a square format. In the foreground, the shapes of the objects go well together, while the color and arrangement of the background enhance the harmony of the whole.

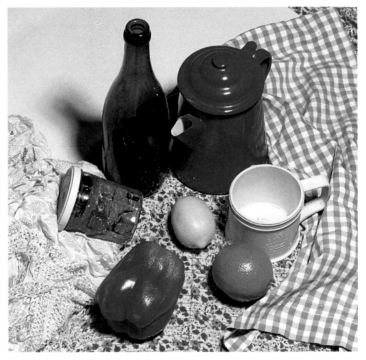

USING A FRONTAL AND HORIZONTAL DESIGN

The value of this is evident in the photograph on the left. Here it is also interesting to decide whether we want to combine the objects with the background or do without one altogether and thereby concentrate on the interesting shapes of the objects. The harmony of color and value plays an important part in the picture. We can leave the ochre canvas unpainted, as the color gives a nice balance to the composition of all white objects.

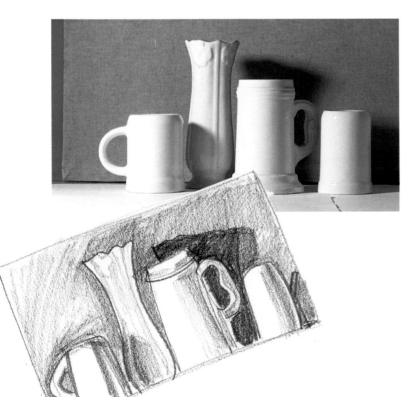

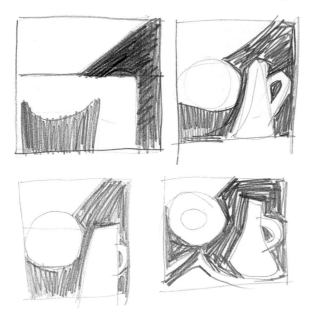

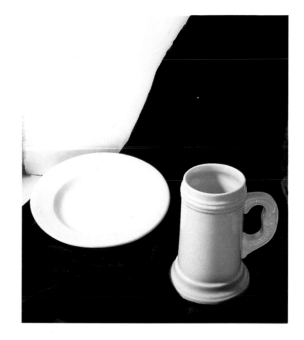

BALANCING FORM AND MASS

These preliminary studies in black and white, with all details eliminated, show how to achieve a good balance of forms and masses in a composition.

COMBINING ELEMENTS OF DESIGN

The composition you can see on the right summarizes everything we have explained up to this point. It is a fine example of the combination of different colors in order to obtain a satisfactory result in terms of rhythm.

In painting, as in music, rhythm is an important element. Rhythm in a painting consists of the strokes, the flow of movement, and the harmony of the composition.

This all goes to prove that in a subject as apparently simple as a still life it is essential to bear in mind all these factors, because each one of them, separately and together, plays a vital role in determining the success or failure of your work.

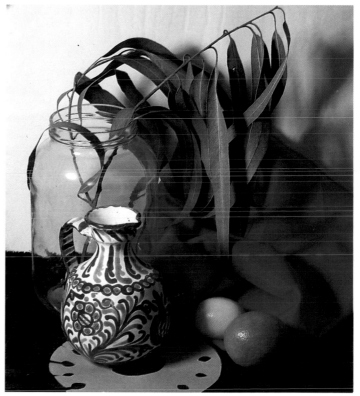

A STILL LIFE IN YELLOW

*T*his exercise will demonstrate how it is possible to mix many variations of one color—in this case, yellow. When painting a group of objects the same color (a jar, several lemons, some flowers, a tablecloth, and a piece of cardboard for the background), it is possible to mix an entire range of shades and values with this one single color. To create contrast, I place several violet-colored (the complementary of yellow) flowers in the setup, and I harmonize them with some carmine-colored ones. With all the elements in place, we are ready to embark on an extremely interesting study.

MATERIALS
- A sketch pad
- A 4B pencil
- A primed white canvas mounted on a 22" × 22" (55 × 55 cm) stretcher
- Hog bristle brushes: numbers 0–18
- Colors: yellow, red, blue, and white
- Palette and palette cups
- Palette knife
- Solvent: turpentine or a substitute

The yellow tones of the flowers stand out against the dull neutral and yellow tones in the background, an effect that brings the flowers to life.

The pinks and mauves harmonize with the warm tones that predominate in the picture, while the cooler violets contrast with yellows, their complementary color.

We arrange the lemons and the jar with the flowers and leaves, so that they stand out against the pale, pastel-like background. The warm tones, together with the greens (yellow with a touch of blue), become the main feature.

1 I begin by studying the distribution of spaces, possible compositions, the dominant colors, the organization of light and shade, the best areas to distribute the primary and complementary colors, and so on.

A

B

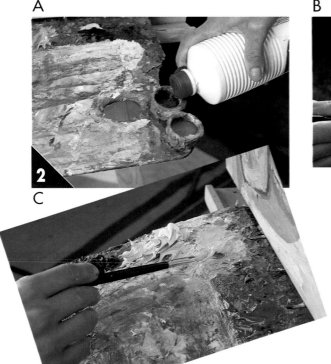

C

D

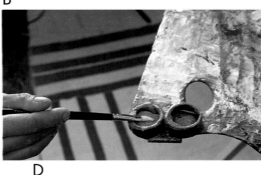

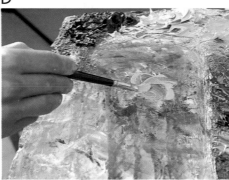

2 I place yellow, red, blue, and white on my palette. Using turpentine, I combine yellow with a touch of red to mix a warmer tone or a touch of blue to mix a cooler yellow. The turpentine enables me to determine how thick or how thin the paint will be.

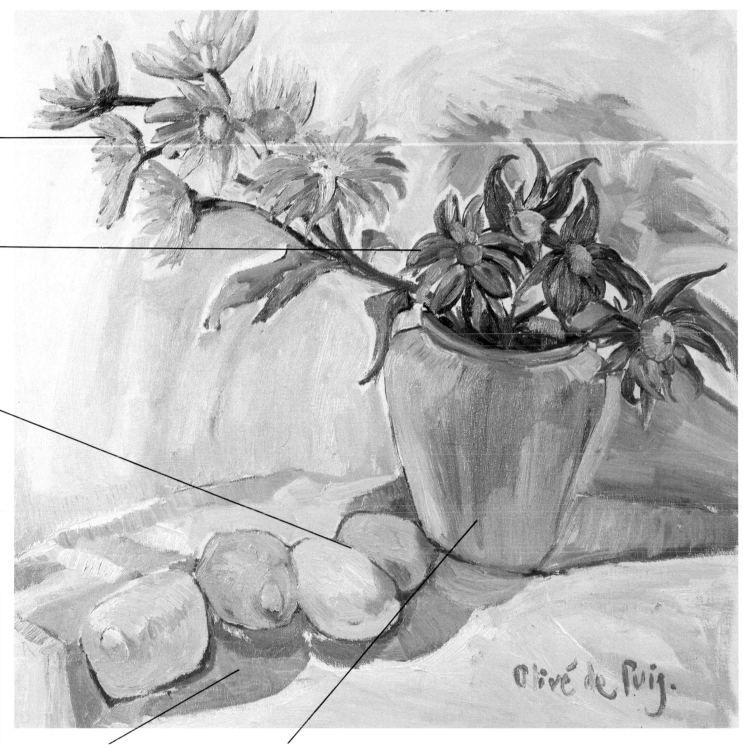

I used an almost transparent greenish blue for the shadows cast by the lemon yellow fruit on the yellow tablecloth.

The orange tone of the vase harmonizes well with the yellow flowers as do the violet flowers with the lemons. There is a good balance of color, which reinforces the diagonal patterns of the composition.

3 To begin the painting, I cover the primed canvas with a diluted uniform yellow tone like that of the still life.

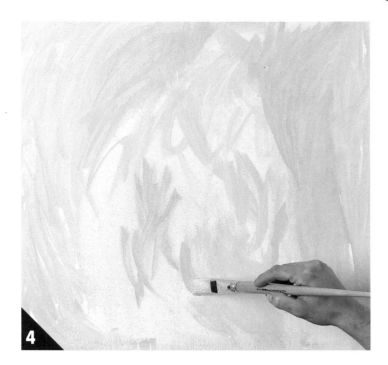

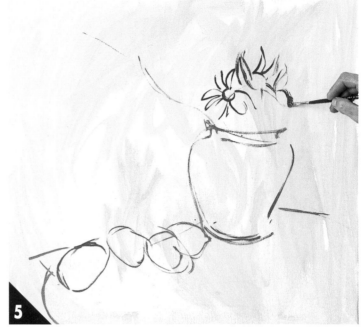

4 I continue covering the entire surface of the canvas with brushstrokes of different yellows. Now I no longer have to worry about covering white areas, and I have a background color that I can easily modify as the painting progresses.

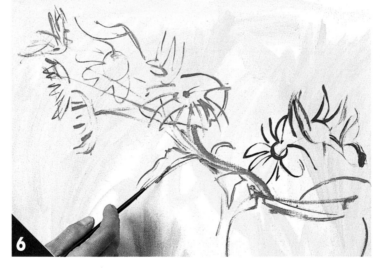

5 I draw the components of the still life with a fine brush loaded with a mauve violet color. Since this is the complementary of yellow, it enables me to work on top of the former color and will help me to create contrast. I dilute my colors with turpentine so they will dry rapidly.

6 I mark out the direction of the petals, leaves, and flowers and look for their movements and rhythms.

7 A few simple lines applied with mauve, violet, and blue stand out on the yellow background.

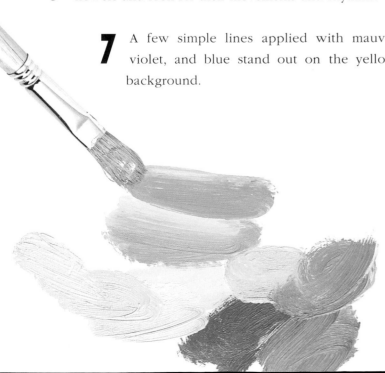

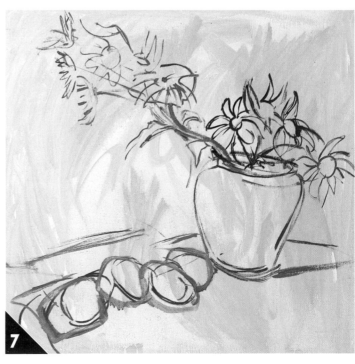

8 I continue the work of outlining the drawing with violet, which I mix using Prussian blue, cadmium red, and white. In this way I get a wide range of yellows combined with the complementary color.

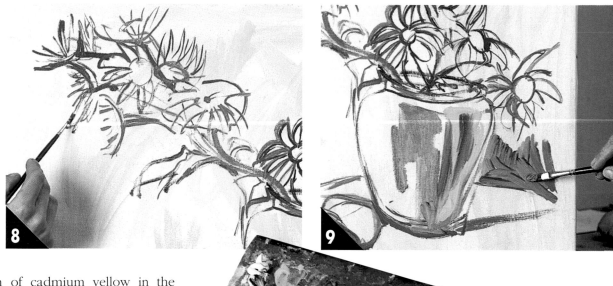

9 Having applied a touch of cadmium yellow in the brightest part of the picture (the daisy), I paint the darkest area (the shadow) with violet.

11 Violet and mauve stand out against the yellow background. I continue working on the violet and mauve flowers in the shadow, the darkest areas of the composition.

10 With the aid of a palette knife, I scrape off the mixtures of paint that I no longer need, to make space on the palette for new mixtures.

THE USE OF BRUSHES

It is preferable to use one brush for each color; this will prevent the colors from becoming muddy. Choose a fine brush for outlining the details of the picture. A thick brush can be used for rapidly filling in large areas.

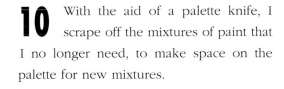

12 Once the darkest values of the shadows are established, I emphasize the highlighted areas of the intense yellow flowers. As you can see, our first task has been to concentrate on defining areas of light and dark.

13 The yellowish pinks are a mixture of pinkish white and cadmium yellow, which harmonizes and brings together the yellow, mauve, and violet flowers.

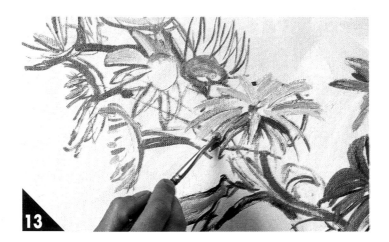

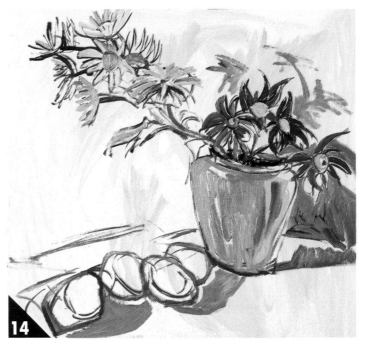

14 The upper diagonal part of the picture (the flowers) is composed of a range of hues that goes from yellow to pink to violet. Next I define the vase. Now the lower diagonal is ready to be painted.

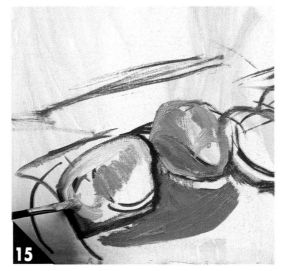

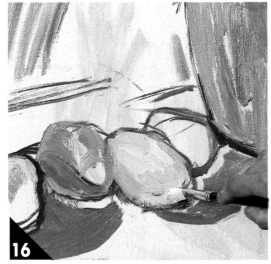

15 I first highlight the different greenish yellows (yellow with a touch of blue) for the shadows cast by the lemons.

16 Small touches of cadmium yellow and lemon yellow and green tones give volume to the fruit and make it stand out against the background.

17 Now I begin to paint in different areas. It is important to work on the picture as a whole, keeping in mind the entire composition. Here part of the background has already been shaded with the same mixtures plus white.

18 To prevent the shadows from being too harsh or too dark, I soften them slightly with a yellow gray, which is a mixture of blue, white, and yellow.

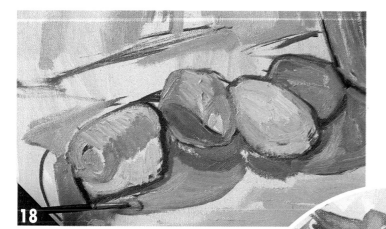

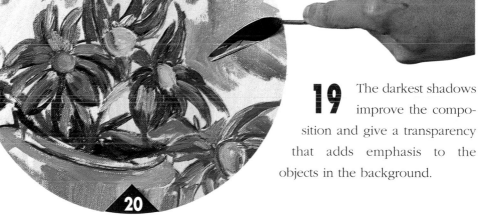

20 The thick paint that has accumulated in the background is removed with a palette knife so that it does not distract attention from the flowers.

21 I do the same in the area of the tablecloth. Here again, like the flowers, the fruit should be the focus of attention.

19 The darkest shadows improve the composition and give a transparency that adds emphasis to the objects in the background.

HOW TO CORRECT A PAINTING

As the paint gradually accumulates on the canvas or when we wish to change from one color to another, we can scrape the paint away and then paint over the area again.

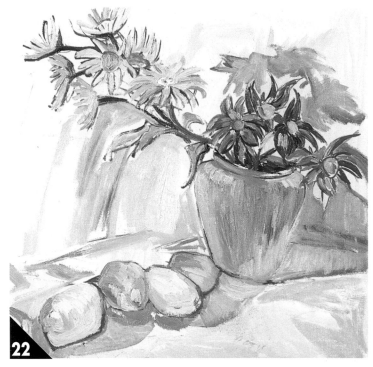

22 The shadows are now lighter and more transparent. They have been corrected with a luminous green that complements the reddish orange and the carmine tones.

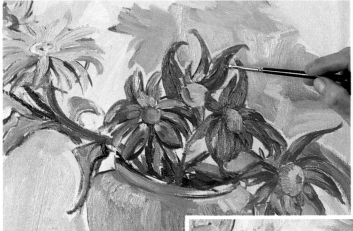

23 I apply several brushstrokes to vary the range of bluish grays, which contrast with the orange, green, and yellow tones in the vase, thus creating rich variations of color and value.

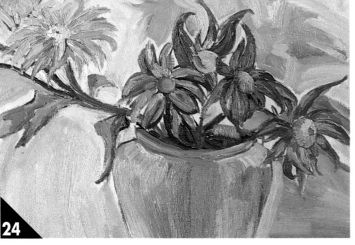

24 These flowers have been painted with warm and cool tones blended together to highlight and balance each other. A few strokes of dark blue in the mouth of the vase contrast with the orange on its outer surface.

25 This color study is now complete. From a base of yellow tones, with touches of red and blue, we have created a range of harmonizing colors and values in the painting.

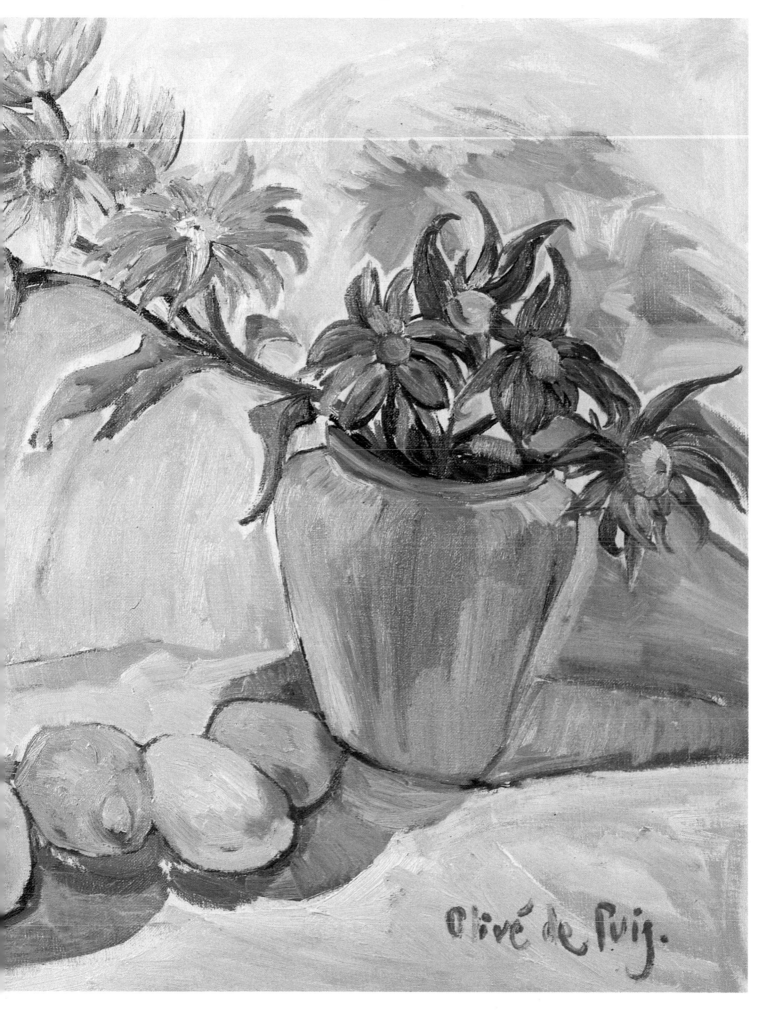

olivé de Puig.

A STILL LIFE IN RED

*T*he following exercise deals with a still life in red. Although the elements of this still life appear similar in color, when placed together, each one of them has its own particular tone, including the background. I have added a green tomato, which, thanks to its complementary color, goes perfectly with the rest of the objects. Let's get down to work.

MATERIALS

- A sketch pad
- A 4B pencil
- A primed white burlap canvas 18″ × 22″ (46 × 55 cm)
- Charcoal stick
- Rag for erasing the charcoal dust
- Colors: white, yellow, orange, red, permanent rose, alizarin crimson, ochre, blue, ultramarine light, ultramarine deep, Prussian blue, dark and pale green
- Turpentine or a substitute
- Brushes: thick and fine, numbers 6, 8, 18

Once they have been studied, worked, and defined, the figure and background show interesting variations of different reds.

The alizarin crimson and violet form part of the same family of reds and warm colors and are differentiated from the other colors here.

The green that surrounds the tomatoes creates a contrast that makes the reds vibrate.

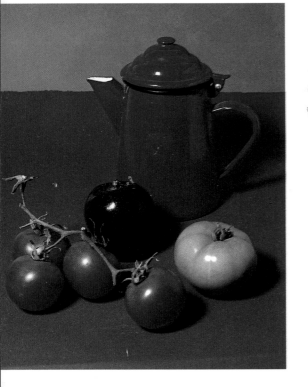

1 The first thing I do is make a few sketches on my drawing pad. I look for the most suitable format, according to the distribution of the elements and draw several variations. It may be horizontal or vertical, taking into account the most appropriate composition.

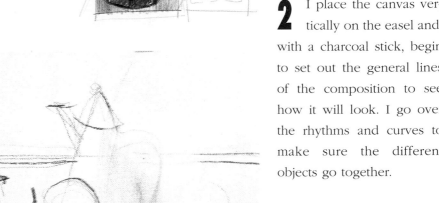

2 I place the canvas vertically on the easel and, with a charcoal stick, begin to set out the general lines of the composition to see how it will look. I go over the rhythms and curves to make sure the different objects go together.

3 Since I am not very enthusiastic about this composition, I erase the drawing with a clean rag and start over again.

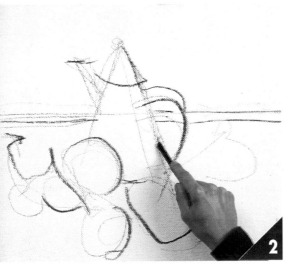

A STILL LIFE IN RED

4 I like this one better. This time I have drawn the subject matter with the canvas in a vertical position. The composition now forms a pyramid, from the highest point of the coffeepot to the lowest area of the canvas.

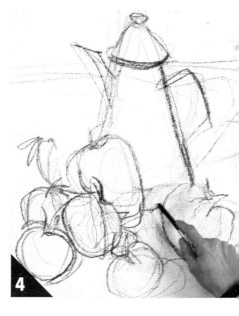

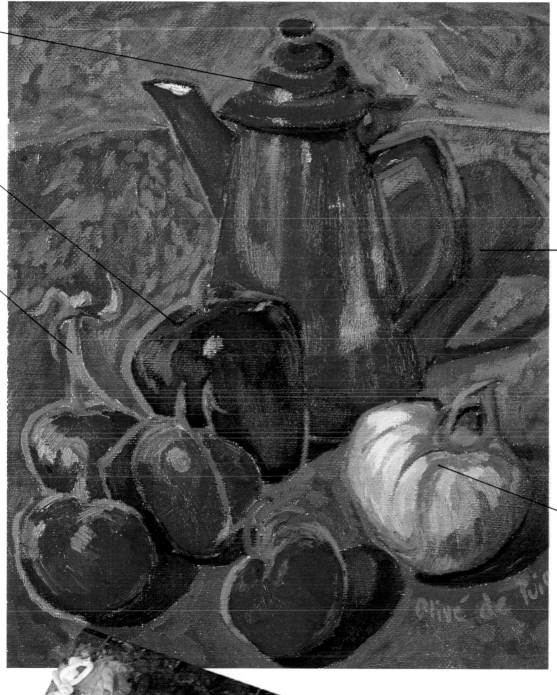

The shadows are dark, but not as intense as the dark area of the coffeepot, which enhances the range of color and value.

The varied red tones are balanced by their complementary color, green. This creates a contrast that breaks the monotony of so many red tones together, especially the hue in the coffeepot and the tomatoes on the left.

5 I mix some dark green, Prussian blue, and white with a little yellow to obtain a vibrant green that I combine with the red tones. I go over the lines sketched in charcoal with the same color.

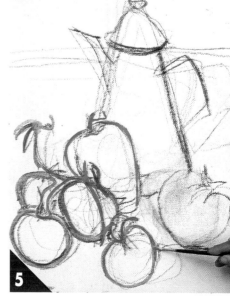

6 Since I have been using green diluted with turpentine, I can now erase the lines of charcoal with a rag, because the paint is practically dry.

7 Now it is time to begin filling in the shadows with dark red and blue tones.

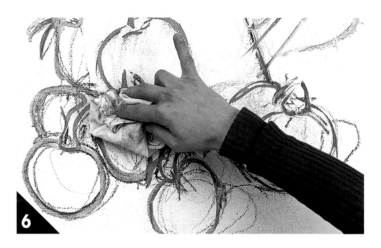

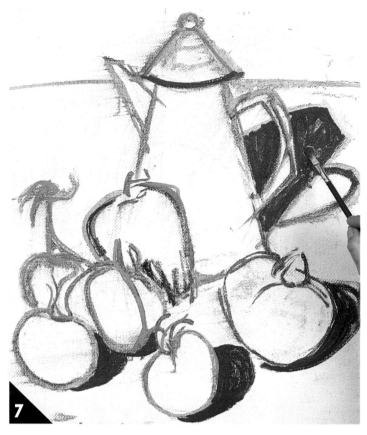

8 I continue to explore the shades and values of cadmium red, alizarin crimson, and violet

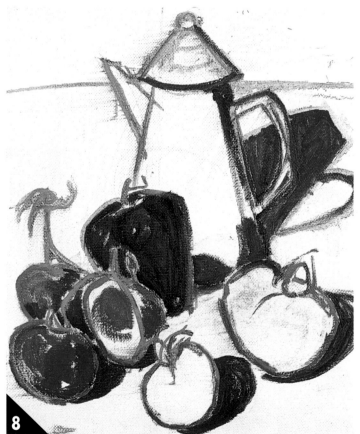

9 I paint the green tomato. It harmonizes with the green used to outline the objects in the drawing, and contrasts with the red tones.

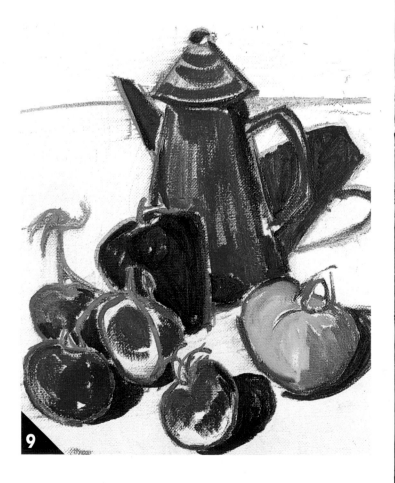

10 I fill in the top part of the background, which is above the green horizon line, and work my way down to the lower area.

11 The picture is now a multitude of red tones, just as I had planned.

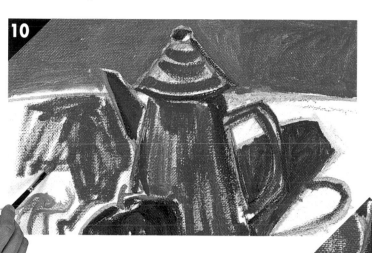

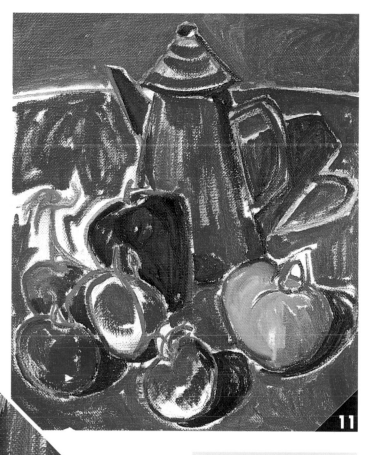

12 Now I am painting with more care, working on the individual pieces of fruit and the light and shadow to suggest form through color.

BRUSHES FOR BURLAP

Stiff bristle brushes, such as hog bristle, are necessary for painting on burlap, because this material has a coarse texture and a porous surface that is difficult to fill with paint. This is especially true if you attempt to paint with anything finer than the brushes we have just mentioned, because they are unable to cover a rough surface like this.

13 With a yellowish green tone I try to capture the lighted area of the green tomato and the dark part, where the reds are reflected. The effect of light and shadow heightens the feeling of form and volume.

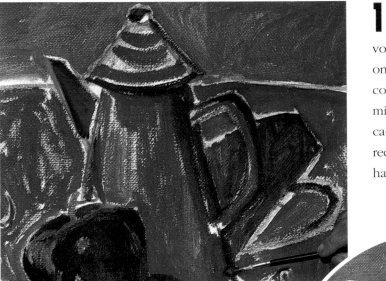

14 The fruit appears to have more form and volume. Now I go to work on the darker areas of the coffeepot. I use different mixtures of alizarin crimson, cadmium red light, cadmium red deep, and blue to enhance the curves of the pot.

HOW TO TAKE ADVANTAGE OF THE COLORS ON YOUR PALETTE

When there is no space on your palette for new mixtures and you want to take advantage of certain oil colors, and avoid wasting expensive paint, you can scrape the paint away with a palette knife and use it to prime a new canvas.

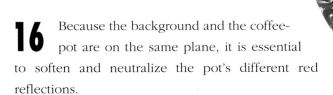

16 Because the background and the coffeepot are on the same plane, it is essential to soften and neutralize the pot's different red reflections.

15 In these areas of shadow that have been painted in tones of violet, I add a little orange to soften and enhance the background.

17 The red and orange reflections on the bottom half of the green tomato give a sense of form and volume. I add a touch of yellow in the top left-hand area.

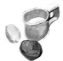

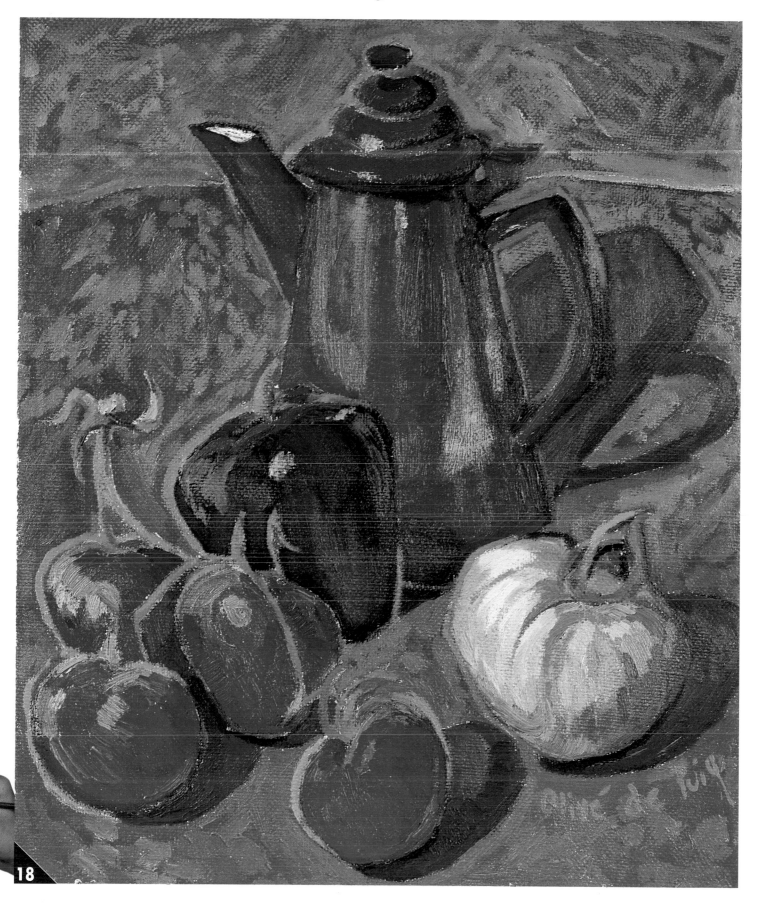

18 It is essential to observe the objects carefully in this type of still life to prevent them from disappearing into the background. Study them closely to detect the subtle changes in tone. The loose green brushwork in the background has no other purpose than that of adding a touch of vibrancy to the picture.

A STILL LIFE IN BLUE

*T*his time we are going to try our hand at a picture containing variations of blue, differentiating between the darkest and lightest values of these colors in relation to orange, their complementary color. I arrange three paint jars, each of which contains a different tone of blue. The two oranges on a white plate will create a bright area in the picture. A dark handkerchief surrounds the elements, all of which are placed on a pale blue table-cloth with red lines, against a gray background.

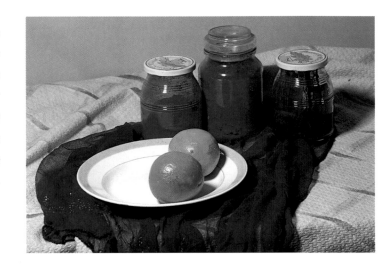

MATERIALS

- A sketch pad
- A white canvas 18" × 22" (46 × 55 cm)
- Colors: white, yellow, orange, red, cadmium red, cerulean blue, ultramarine light, ultramarine deep, Prussian blue, dark and pale green, black
- Rags
- Charcoal stick
- Turpentine or a substitute
- Brushes (0–18)

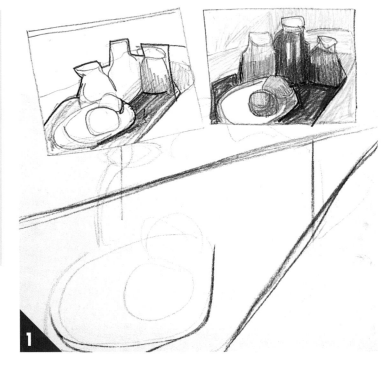

1 I do a preliminary study on my drawing pad, first indicating the dark values and then painting the different blue and orange areas. Next I place the canvas on the easel and draw two lines to indicate the dark areas of the still life and the edge of the plate, whose white surface will stand out.

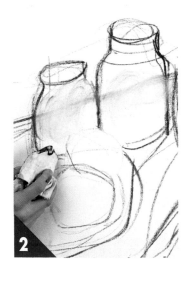

2 Any corrections can be easily made by rubbing a clean dry rag over the charcoal lines.

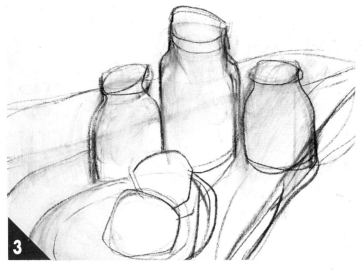

The plate is the lightest area of the picture, but although it appears to be white, it actually contains subtle tones of other colors.

Because the top part of the jar is transparent, it has been shaded with gray, just like the background.

The violet reflections on the reddish orange were a mixture of orange and blue.

This dark area also serves to join the two diagonal lines that make up the composition; these are balanced in turn by the red lines that intersect them.

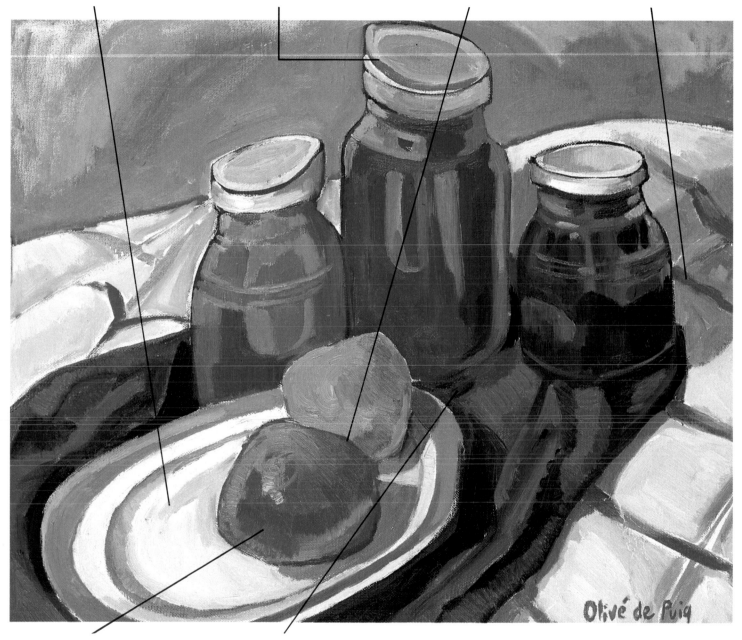

Olivé de Puig

The red and orange tones of the fruit repeat the red lines of the tablecloth.

Darker values of blue can be obtained by mixing it with other colors, exactly as I have done here, using black, red, green, etc.

3 The finished charcoal sketch shows all the elements in place. I have stylized the bottles and exaggerated the shape of the plate to improve the composition.

4 Using a brush loaded with turpentine, I go over the charcoal lines and the oranges.

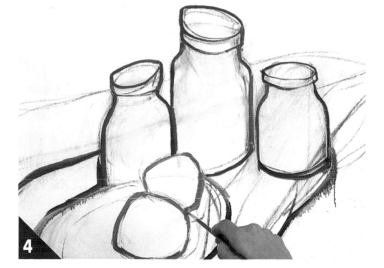

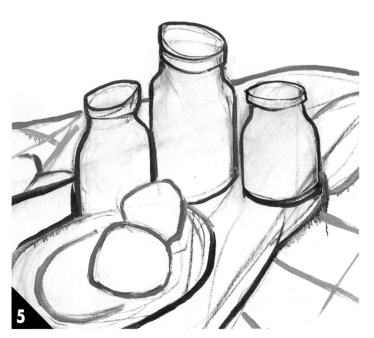

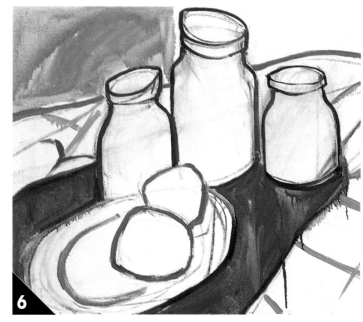

5 Thanks to their color, the lines perpendicular to the diagonals that outline the group of elements enhance the composition's balance.

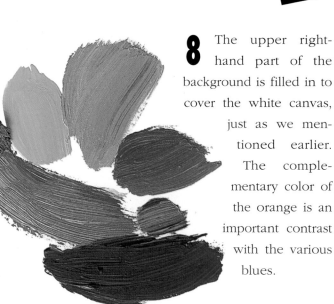

7 These areas are now painted with the dominant blues. These patches of color are painted with very diluted paint, which provides us with a good base on which we can begin to bring out the different hues.

6 We outline the white areas of the canvas by painting the largest masses of color—the area of ultramarine deep that surrounds the objects and part of the background that has been painted in a gray, which I mix from blue, white, and red.

8 The upper right-hand part of the background is filled in to cover the white canvas, just as we mentioned earlier. The complementary color of the orange is an important contrast with the various blues.

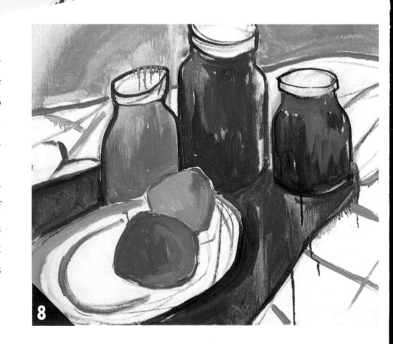

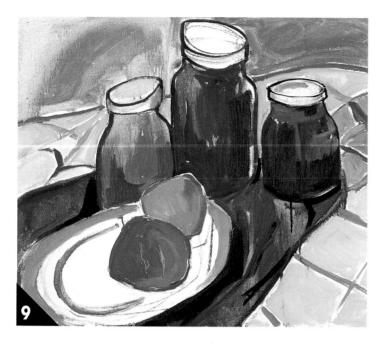

9 With the addition of a greenish blue tone—a mixture of Prussian blue, dark green, and white—the picture appears almost complete. The only remaining work involves the white areas.

11 This is my studio, where I spend as much time as possible. No matter how insignificant or humble your studio may be, if you can set up an easel and a still life there, you can create as intimate an atmosphere as you see here.

HOW TO TONE A CANVAS

To tone the canvas, you should apply a color thinned with turpentine over the entire surface. Diluted paint dries quickly and leaves an almost transparent layer of paint that also provides us with a background color.

10 Here I am modifying the white tone of the canvas in the area of the lid, using variations of warm whites (white, red, yellow, and blue). I paint both the highlighted and shaded parts of the lid.

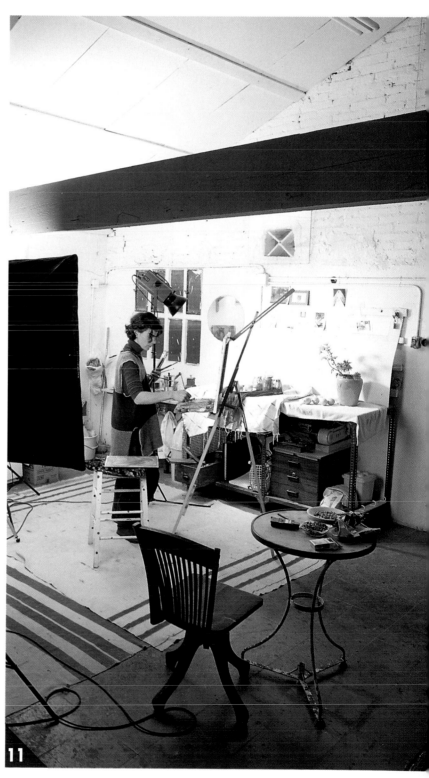

HOW TO PAINT SHADOWS

If we mix the color of an object with some of the background color when both are in direct light, the result will be identical to the color of the shadow. In reality, this is the color we would have if we were to superimpose one of the two lighted parts onto the other.

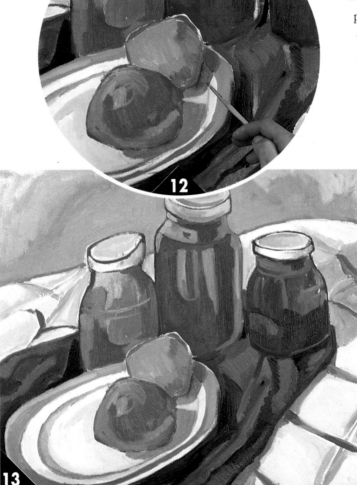

12 With a very fine brush loaded with Prussian blue and white, I paint the curve of the plate. This also creates a contrast with the orange shadows reflected by the fruit.

13 The shadows on the plate are simple tones, mixtures of white, with orange, blue, red, etc.

14 In this photograph you can see the original setup alongside the palette containing the colors I am currently using. The dark blue areas, the light colored plate, the tablecloth, and the vivid orange color stand out.

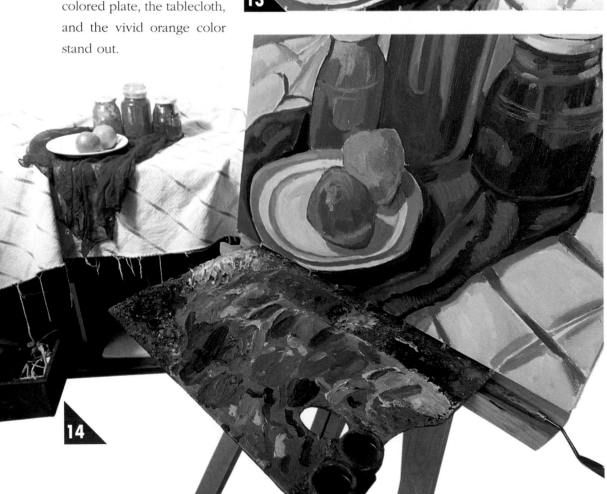

15 These touches of light blue indicate the reflections on the jar on the light part of the tablecloth on the right.

16 I have finished the painting. I believe that everything I set out to do has been accomplished: a harmony of hues and tones of blue contrasted with red and orange.

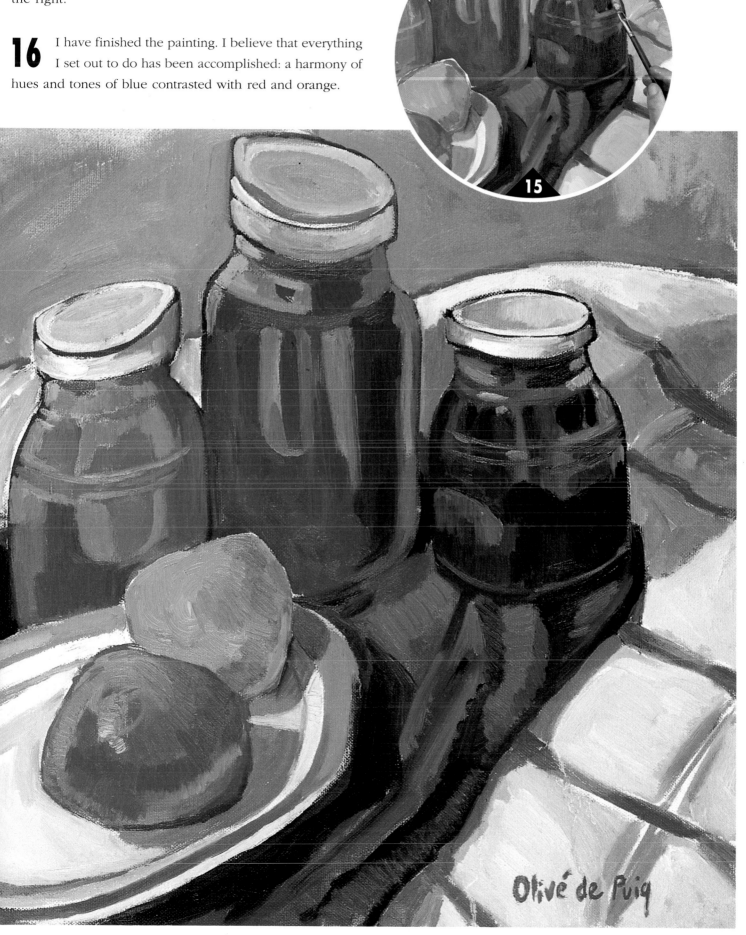

Olivé de Puig

A STILL LIFE PAINTED WITH PRIMARY AND COMPLEMENTARY COLORS

I am going to paint this still life from an elevated point of view. I choose a few things I have handy and arrange them according to their color and shape, with the idea of interspersing the primary and complementary colors as well as playing with the shapes and the background to obtain an interesting composition. Let's get down to the compositional study.

MATERIALS

- A sketch pad
- 4B pencil
- Colored pencils
- A 24" × 24" (60 × 60 cm) cotton canvas
- Colors: white, yellow, orange, red, cadmium red, blue, violet, green
- Brushes
- Rags
- Turpentine or a substitute

The yellow background balances the yellow of the lemon. It stands out because of its color, its position in the center of the picture, and because it is placed next to its complementary color, purple, in the same area.

The green, situated next to its complementary color (red), is balanced by the napkin on the right, which is toned by shades of green.

A
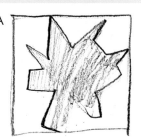

B
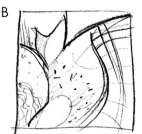

C

D

E
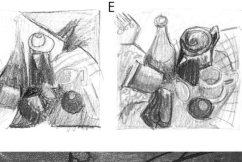

1 I draw a sketch to determine the spatial balance of the still life (A). In a second sketch I analyze the flowing rhythmic lines of the background (B). Last, I combine the components of both foreground and background (C). Now I try to decide what colors I will use to paint this still life. The first one looks promising (D), but I finally choose the second one, because the arrangement of colors is more attractive and balanced (E). I prime the canvas with a layer of paint and turpentine.

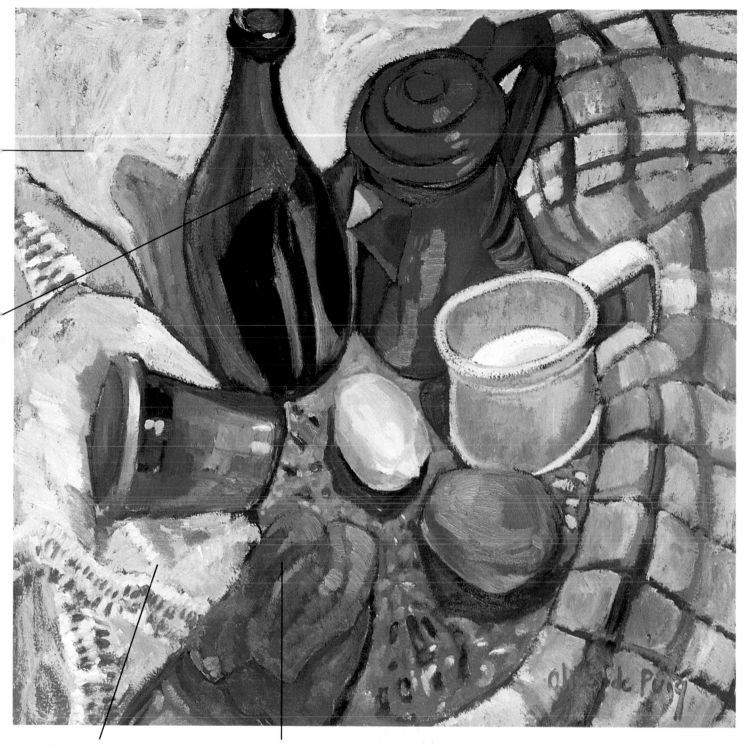

The tablecloth on the left is balanced by the mug on the right. The blue jar in turn blends with the violet tones and is also balanced by the blue tones of the napkin on the right.

The red pepper softens the intense red of the coffeepot and at the same time brings the tones of the orange and lemon closer, thus producing a color gradation.

2 I have used blue, so that it acts as a complementary color, to layout the composition, indicating where the different objects are situated.

3 I continue arranging the objects within the area I designated earlier.

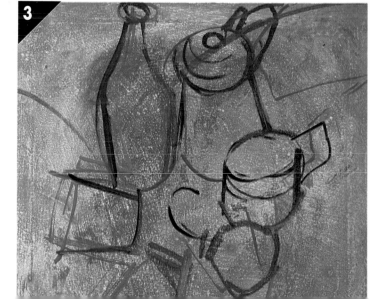

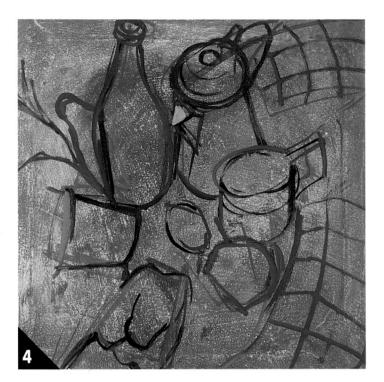

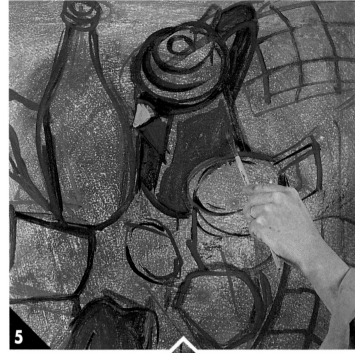

4 I have drawn in the napkin and tablecloths in the background, taking advantage of the flowing lines and patterns of the composition.

5 I apply the first red areas, one in the top part of the picture and another at the bottom.

6 The color of the lemon stands out strikingly, while the orange, a mixture of yellow and red, harmonizes the two primary colors. The pastel yellow in the top part balances the intensity of the colors.

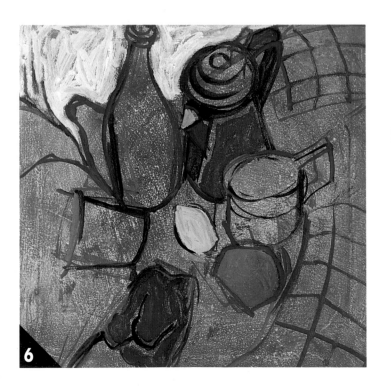

HOW TO TAKE ADVANTAGE OF THE COLORS ON YOUR PALETTE

Sometimes we require a certain value, hue, or color to create a texture or effect. This can be done by taking advantage of the color mixtures we already have on the palette by adding a touch of white, red, alizarin crimson, or green to them, depending on the color we require. This way we can increase the range of tones and achieve a more harmonized picture.

7 I paint the mug with a yellowish white, then I paint two of the napkin's green lines. With a greenish white, I also paint two squares. Blue is an important color in this series of primary and secondary colors.

8 I paint the top half of the bottle with a light green to suggest the yellow background that can be seen through it. The lower part of the bottle is a darker green, blending with the shadows of the objects against the background.

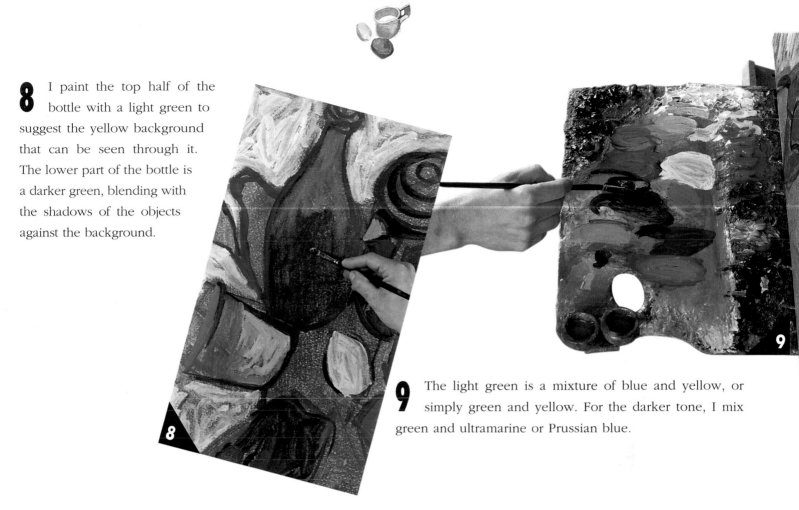

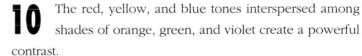

9 The light green is a mixture of blue and yellow, or simply green and yellow. For the darker tone, I mix green and ultramarine or Prussian blue.

10 The red, yellow, and blue tones interspersed among shades of orange, green, and violet create a powerful contrast.

11 I paint the different tones of white that surround this setup after determining whether they are warmer (yellow or red) or cooler (green or blue).

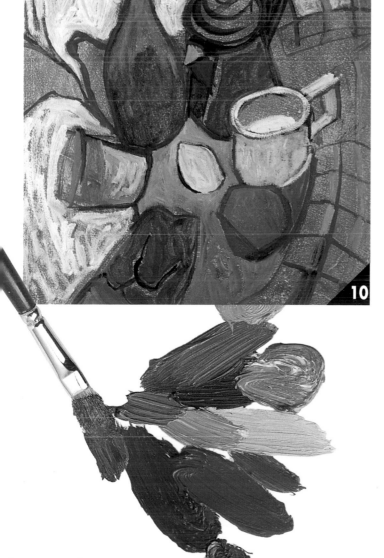

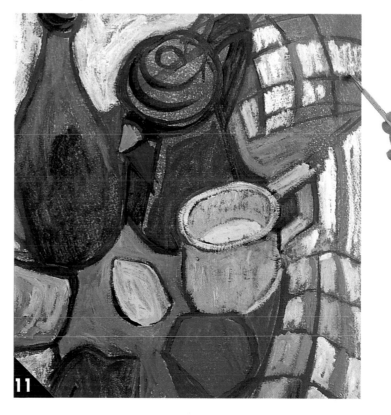

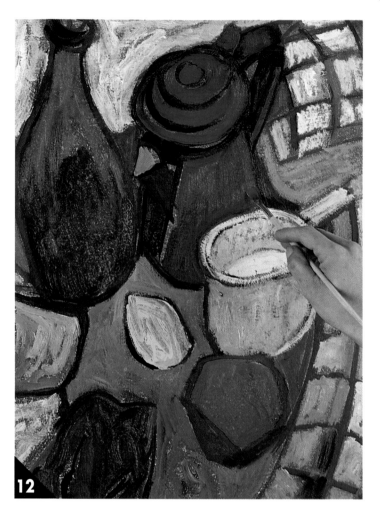

12 After laying out different areas of the painting by color and value, I work on the more subtle hues of each object, such as the red of the coffeepot, a mixture of permanent rose, white, and a touch of blue.

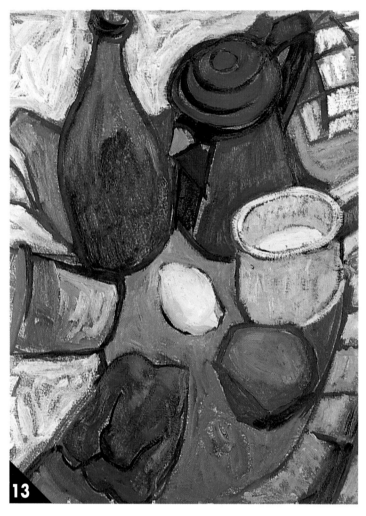

13 I apply a touch of yellow to the lemon and the lighter areas of the red pepper and the orange to enhance the luminosity and rounded shape of these objects.

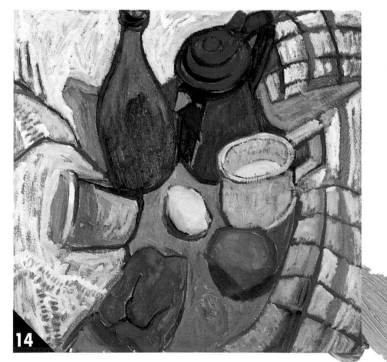

14 The pattern of the tablecloth on the left, painted with small touches of white, is balanced by the squares on the right.

A STILL LIFE PAINTED WITH PRIMARY AND COMPLEMENTARY COLORS

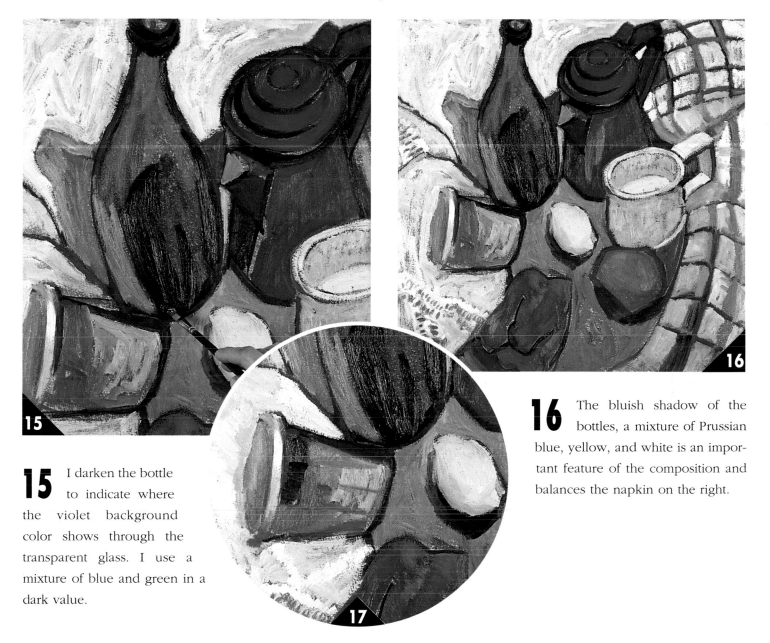

15 I darken the bottle to indicate where the violet background color shows through the transparent glass. I use a mixture of blue and green in a dark value.

16 The bluish shadow of the bottles, a mixture of Prussian blue, yellow, and white is an important feature of the composition and balances the napkin on the right.

17 The lower left-hand part of the bottle produces a greenish white reflection that is visible on the yellowish white tablecloth.

HOW TO MIX WHITES

The white areas in this still life should not be interpreted as being white straight out of the tube. White is always modified by warm or cool reflections cast by nearby objects. Therefore, it must be varied by adding touches of color, that is, white with red, yellow, blue. . .

18 The rounded form of the lemon is emphasized by applications of lemon yellow and white, pastel green, soft orange, and gray. The gray is a mixture of green, orange, and white.

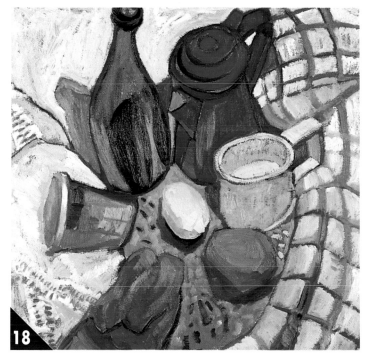

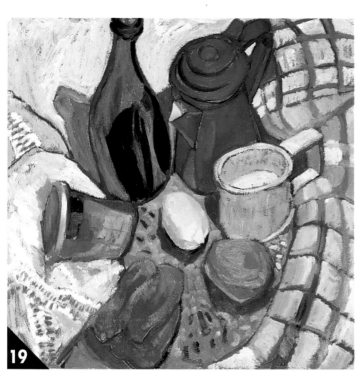

19 The bluish white in the opening of the spout of the coffeepot adds a light accent among this array of different colors and goes well with the white areas of the napkin and tablecloths. This distribution of whites gives the picture an excellent color harmony.

20 On the front of the coffeepot I paint several brush-strokes of orange (a mixture of red and yellow) to depict the reflection of the lemon. On the other side, I add tones of violet where the dark mauve tablecloth is reflected in the pot.

21 The bright colored lemon is also reflected along the lower left-hand side of the mug. I use several strokes of yellow to produce this effect.

22 The painting is now finished. We think it is an excel-lent study of composition, rhythm, and balance. The interspersing of primary and complementary colors creates a magnificent display of light and color.

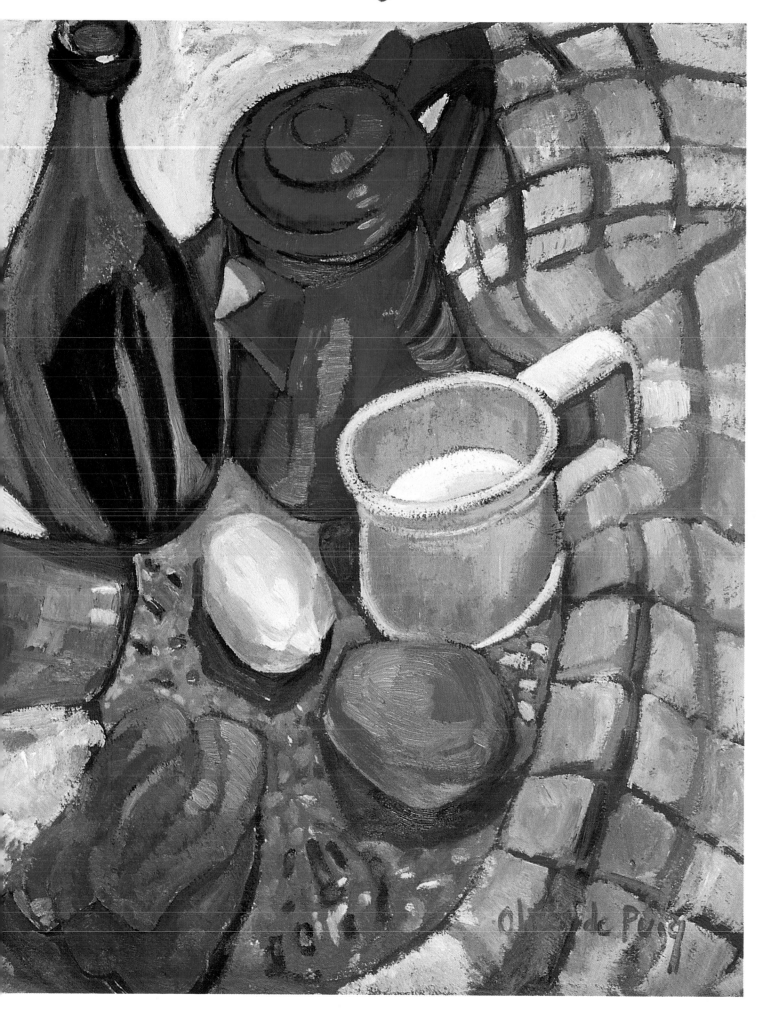

A STILL LIFE IN WHITES

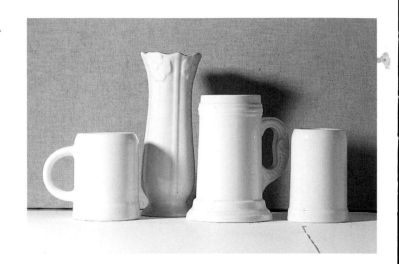

*W**ith** this still life we will carry out a study of different tones of white and gray, which may all appear to be identical at first, but are really different. If we place various objects of the same color together, we will see the subtle differences in value and hue of each one. To demonstrate this, I place four white ceramic objects next to each other in front of a beige background, the color of my canvas. The light that illuminates the objects will help us to differentiate between the subtle warm and cool tones.*

MATERIALS

- A beige linen canvas 14" × 24" (36 × 61 cm)
- Colors: white, yellow, red, ochre, sienna, permanent rose, burnt umber, blues, and greens
- Brushes: hog bristle, numbers 0–14
- Turpentine
- Palette cups
- Pencil

1 The first sketch is to set out the general distribution of the objects. We can choose to cut them off at the bottom or include their entire length. Another question is whether to shade in the object and the background or only outline them.

2 I draw the elements with a pencil to avoid getting the canvas dirty.

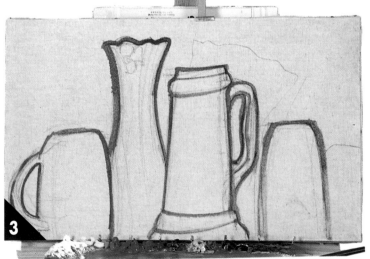

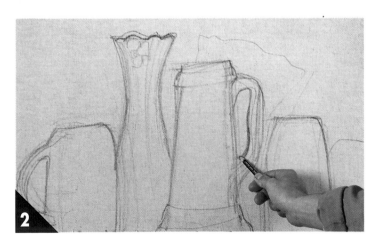

3 I outline the objects with burnt sienna, using a tone similar to that of the background.

The beige tone of the canvas harmonizes perfectly and enhances the composition.

The yellow in the vase makes the different white tones stand out.

This white has subtle green tones that are not present in any of the other objects.

The burnt sienna shadow blends perfectly with the color of the canvas.

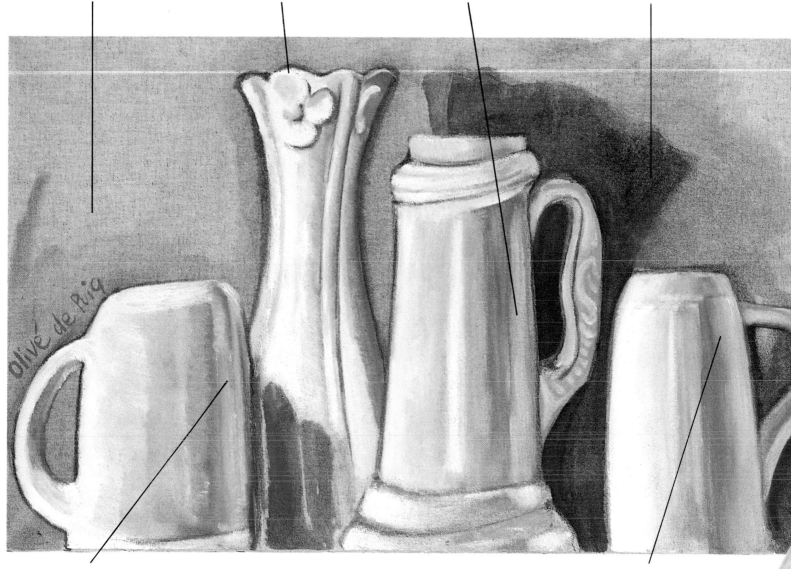

The blue tones in this area are balanced by the handles of the two mugs on the right, which are also blue. When combined, these three tones of the same color help to enhance the picture.

The pink reflection that can be seen is due to the effect of the light, which gives the picture a warm tone.

4 I paint the shadows of the objects and the wall in a neutral rose tone thinned with turpentine. I want to keep the painting within a range of neutral earth tones.

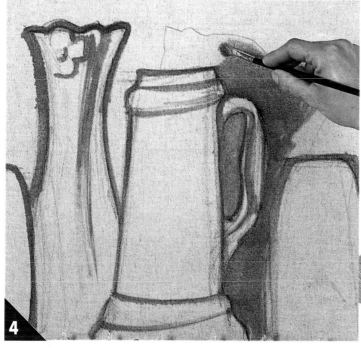

5 Now we begin painting white over the entire surface of the mug. This is the basic color I will use to see what effect it creates.

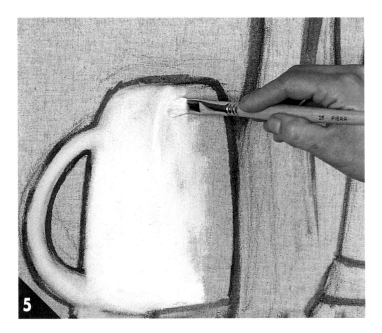

6 I do the same with the vase, only here I add a touch of yellow in an attempt to suggest the tonal difference between this object and the mug.

7 There is a somewhat blue tone present on the handle of this mug.

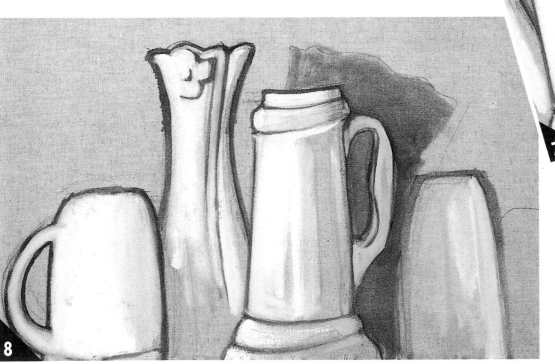

8 Here, the different tones of white are established. Some are warm white, others are cool white, depending on the addition of yellow, blue, or red.

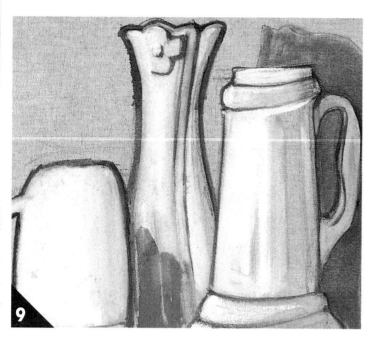

9 The shadow I have added to the vase, a mixture of white, blue, red, and yellow, helps to position the mug on the left.

10 I paint in a shadow to bring out the three dimensional form of the jar on the right with white, a touch of blue, yellow, and a little red.

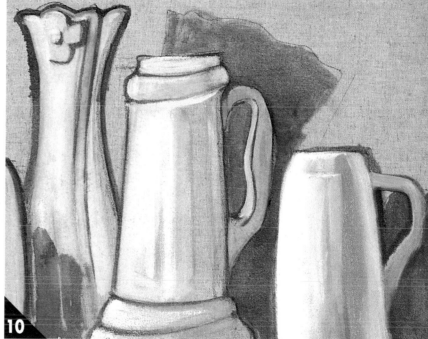

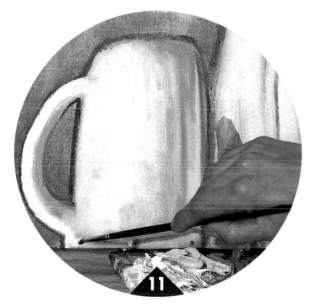

11 I use pure white to add emphasis to this important light zone.

HOW TO DIFFERENTIATE WHITES

If we place some white from the tube alongside the other white mixtures, you will see that these are really gray. Some of them are warmer and others are cooler. These different tones are mixed by adding color to the white paint, whether it be red, green, etc.

12 The white tones that were applied earlier have now taken on a gray appearance when compared to the pure white on the palette. By adding tiny amounts of other colors to white, the mixture will gradually acquire a gray appearance.

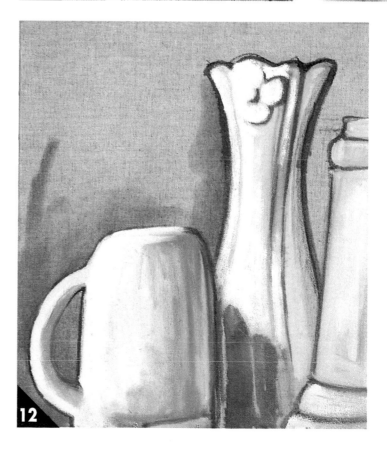

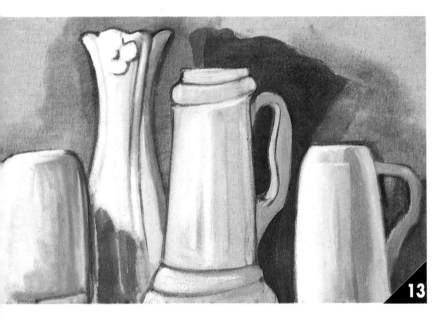

13 We can see here how the mug gradually becomes darker on the right side due to the gray, green, and red tones. The shadows in the background are darkened to add emphasis to the objects.

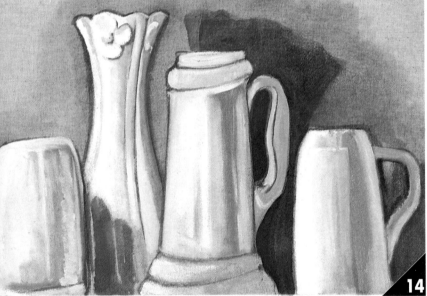

14 We use a mixture of white, red, blue, and yellow for the dark shadow along the unlighted area of the tallest mug. In this way, I slowly develop the rounded form of the object.

HOW TO MIX GRAY

Black should never be used to mix different tones of gray, not even for dark values. When mixed and combined correctly, yellow, red, and blue provide us with a wide range of gray tones. For a light value of gray we should add more white, while a darker value requires more red, blue, green, alizarin crimson, or burnt sienna.

The inclusion of the design of the handle gives the picture a special touch. Another feature is the soft- of the shadows, which were applied with paint thinned turpentine.

Our study of the use of white and variations of white is at an end. Despite the simplicity of the composition the elements within it, we can see how the objects and background are integrated through subtle and trans- nt changes in tone and hue. A few strokes in earth tones as burnt sienna surround the objects without changing color and value of the canvas. This is a simple picture se end result is an excellent lesson in understanding r, tone, and value.

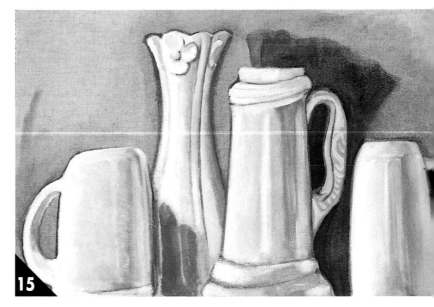

15

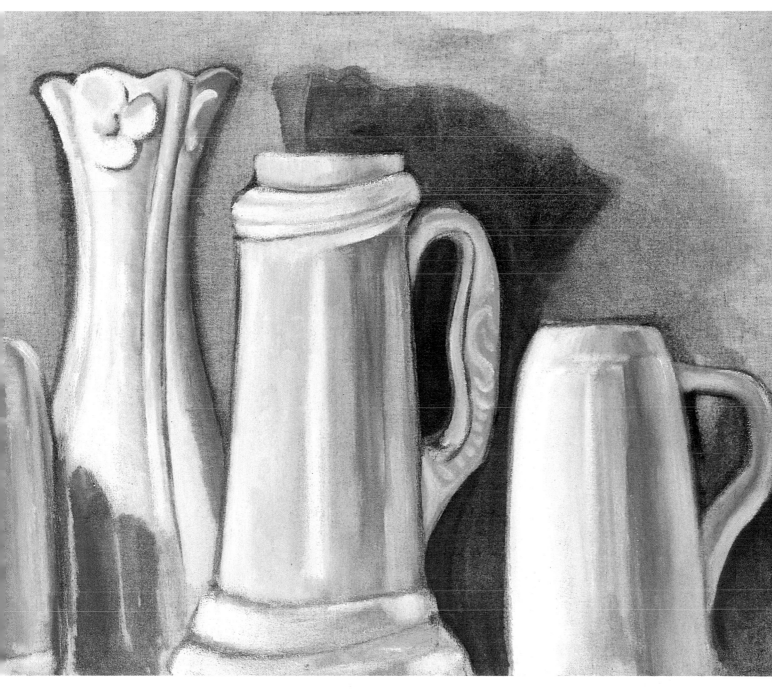

A STILL LIFE IN BLACK AND WHITE

I *n this exercise, I plan to carry out a study in black and white. The composition consists of large areas of black and white, as well as variations of each color. The still life setup is a simple one, with dramatic contrasts. It consists of a plate and a mug placed on a black drape against a white background. The aim of this exercise is to do without colored objects, since we have covered that subject in earlier exercises, and to discover the many possibilities that black and white have to offer.*

MATERIALS

- A burlap canvas primed with rabbit skin glue and gesso 18″ × 18″ (46 × 46 cm)
- Charcoal
- Colors: white, yellow, red, burnt sienna, blue, and black
- Turpentine
- Palette cups
- Brushes: hog bristle, numbers 0–16

The white background painted with a greenish tin that the white plate app brighter.

The plate, from above, i essential feature in this abs composition.

Various blacks, toned blue, green, red, ochre, a little white, represent the ill nated areas of black.

1 It is essential to b out the areas of b and white in your ske The white table should up the same amoun space as the black drap order to obtain a bala composition.

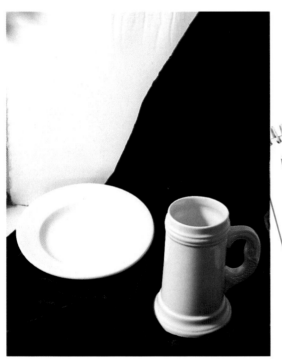

2 We use charcoal to shade in the black area occupied by the drape. Note how the plate is depicted with a simple line and how the base of the mug is cut off. The contrast of black and white creates a perfect balance of color and value.

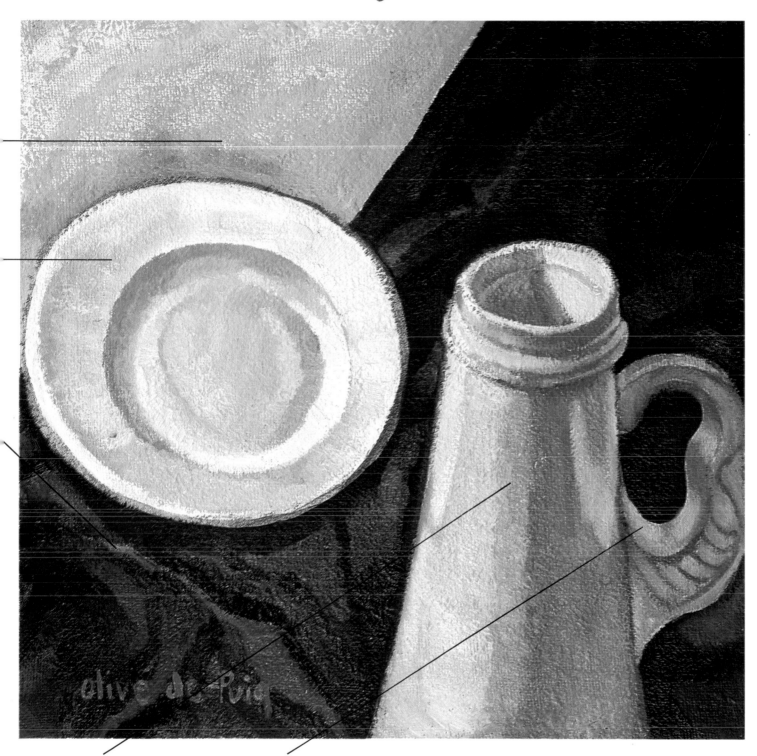

The mug, which has been deliberately cut off at the bottom, adds a note of color to the entire picture with the warm tones and the variations of blue, violet, and green on its right-hand side.

Yellow and rose tones are used to suggest the reflected light of the lamp.

3 I outline the objects with a line of black paint thinned with turpentine.

4 I lay in the area of the black tablecloth in order to evaluate the effect of the composition.

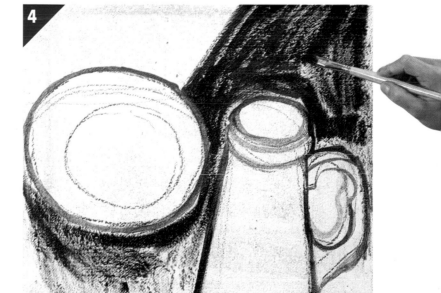

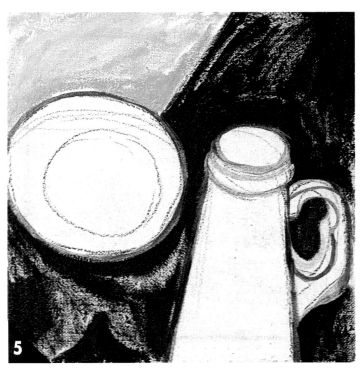

5 Here you can see how I have laid out the black background, showing both highlighted and dark areas of the tablecloth. The surface of the canvas is left partly visible, whereas the wall, which forms part of the lightest area, is painted a greenish tone.

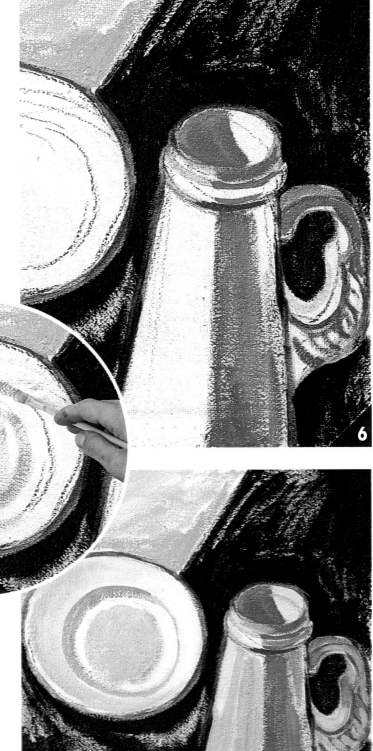

6 The greenish shadow in the mouth of the mug is a mixture of white, blue, and ochre.

7 I paint the circular shadows on the plate in a mixture of yellow, red, blue, and white. This neutral gray helps to define the darkest areas in the center of the plate.

8 As the painting progresses, we can see how the white plate and mug have been developed by adding a soft violet tone in the shadowed areas and a touch of yellow in the highlighted areas.

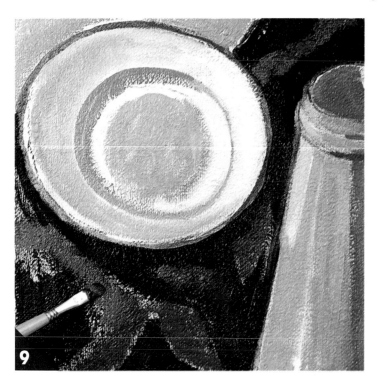

9 I increase the range of grays by adding alizarin crimson and blue to the mug and the illuminated part of the drape. This enables us to give the work more light and at the same time enhances the color range of the white plate and mug.

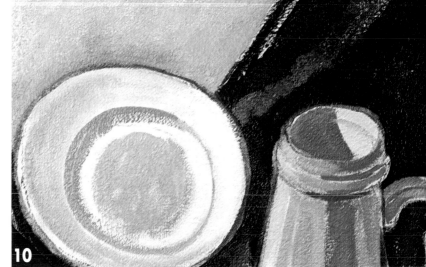

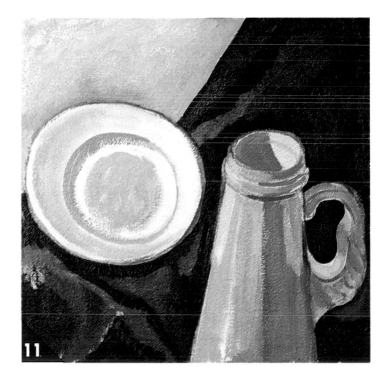

THE USE OF BLACK

Black is used to mix very dark grays of different tones. For example, we can mix a yellowish black by combining black with ochre or yellow, or a reddish black by mixing it with orange or carmine, and so on. If you look closely at the color black that appears in the objects, you will see how this color is never pure, it is always modified with touches of other colors.

10 Different hues have been used to paint the white areas. The highlighted part of the plate is painted with a mixture of white with a touch of yellow. The original line of gray that defines the bottom of the plate is left untouched.

11 The white areas are darkened and the dark areas are lightened. In this way, these two flat masses gradually develop a three dimensional appearance.

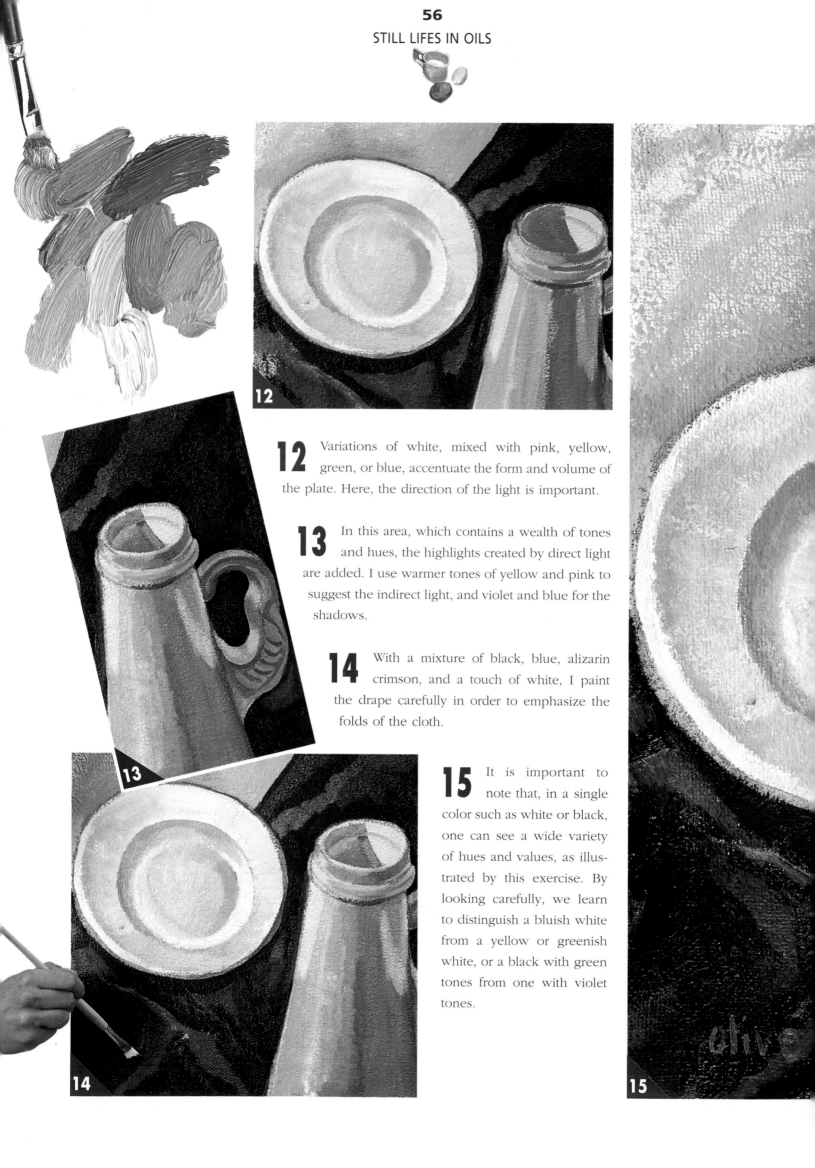

12 Variations of white, mixed with pink, yellow, green, or blue, accentuate the form and volume of the plate. Here, the direction of the light is important.

13 In this area, which contains a wealth of tones and hues, the highlights created by direct light are added. I use warmer tones of yellow and pink to suggest the indirect light, and violet and blue for the shadows.

14 With a mixture of black, blue, alizarin crimson, and a touch of white, I paint the drape carefully in order to emphasize the folds of the cloth.

15 It is important to note that, in a single color such as white or black, one can see a wide variety of hues and values, as illustrated by this exercise. By looking carefully, we learn to distinguish a bluish white from a yellow or greenish white, or a black with green tones from one with violet tones.

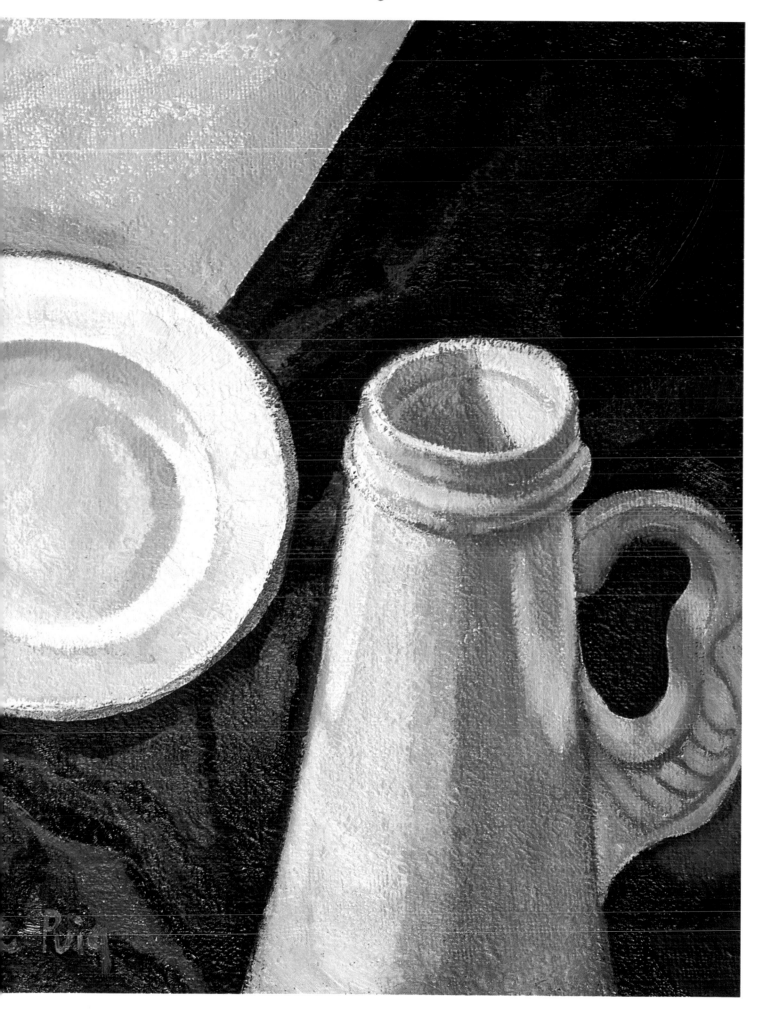

A STILL LIFE WITH ALL COLORS

*T*his exercise involves painting a still life using all the colors we have studied throughout the pages of this book. We will also paint it over a used canvas. I organize the composition according to the lines and movements of the green leaves, their shadows, the transparent jar, the red drape, the fruit, and a jug, which stands on a lilac-colored cardboard doily.

MATERIALS

- A sketch pad
- A used white canvas, 24″ × 28″ (60 × 73 cm)
- Brushes: numbers 0–18
- Colors: black, white, yellow, red, and blue
- Turpentine
- Charcoal stick

Red, blue, and silvery tones trace the movement and positions of the leaves. Therefore, in the soft tones of this dimly lit area, we can see delicate nuances of color.

The white jug, casting its shadow on the lilac doily, appears to be dancing with the lemon and the orange. The deliberate distortion of the jug also serves to enhance the sensation of movement.

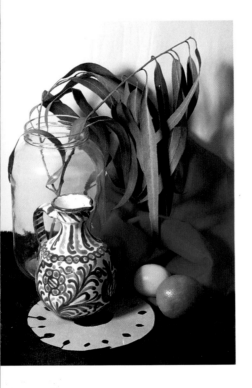

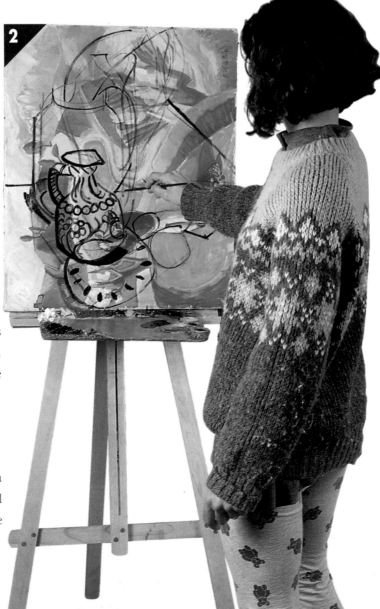

1 With a drawing pad and charcoal, I sketch the movement and rhythm that the still life setup conveys to me, as well as the relationship of light and dark areas. Once this has been completed the picture is ready to be painted.

2 I paint this new still life on top of a used canvas—a painting I don't wish to save. First I draw the principal lines with charcoal, then I go over them in black with a fine brush.

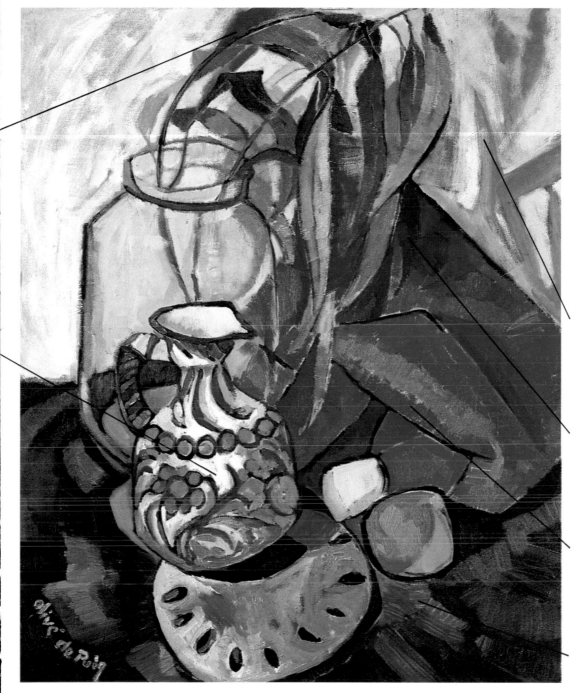

The leaves and shadows painted in different colors give the composition a feeling of movement.

Small strokes of alizarin crimson darken the edge of the bright red drape and blend in with the leaves.

A stiff fold in the drape creates an abstract form consisting of different cadmium red tones.

Brushstrokes of a warm tone in a dark value add texture and color to the black background.

3 I want to cover the previous painting as quickly as possible, so I paint the lilac doily first. For the side in full light, I use a mixture of alizarin crimson, Prussian blue, and white. For the side in shadow, I mix alizarin crimson, blue, white, and yellow.

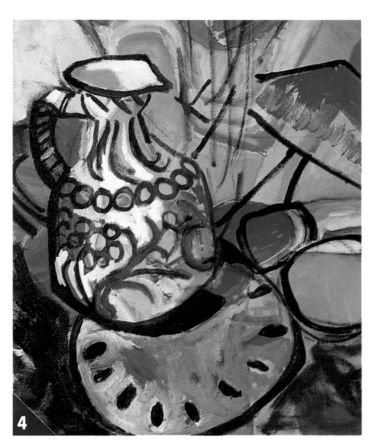

4 I paint in the white areas of the jug in order to cover the green background remaining on the used canvas. Next I begin to emphasize the rounded shape of the jar by adding the blue decorations and the violet shadows.

HOW TO TAKE ADVANTAGE OF A USED CANVAS

You may find it disconcerting to work on a used canvas. Therefore, it is important to cover the canvas as quickly as possible with a single color to form a uniform background on which we can begin our new picture. But we may also take advantage of the colors of the previous picture, if we see that they are suitable for the work we are carrying out.

5 I apply the various red tones on the drape using cadmium red light, burnt sienna, blue, and orange in a very direct way to cover up the background.

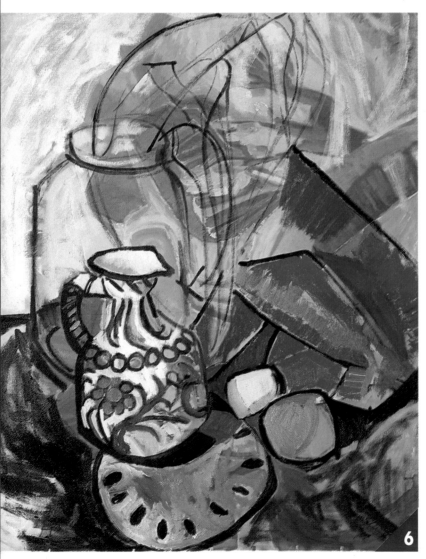

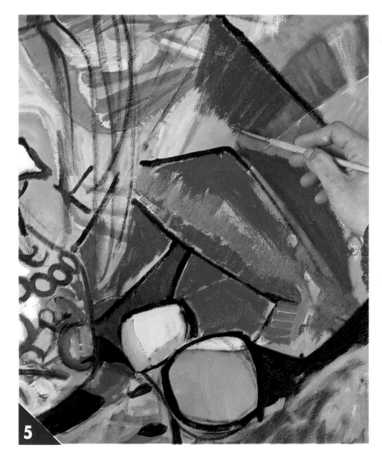

6 In the area where the leaves will be placed, I leave the green paint of the former painting.

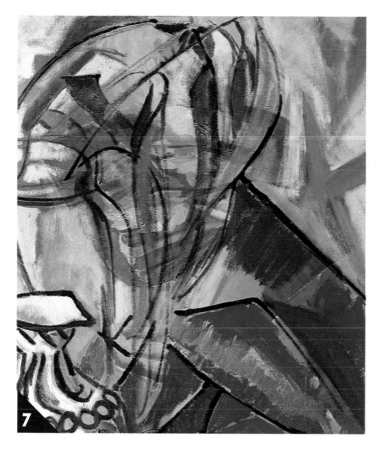

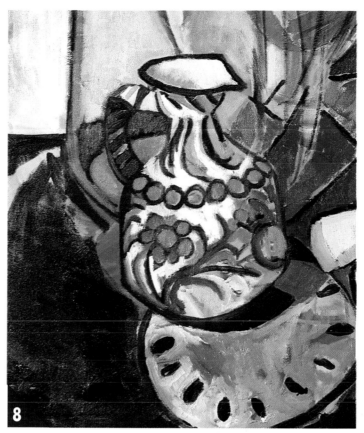

7 I paint the shadowed areas of the leaves in a dark value of green. Then I fill in the grayish white background, seen between the leaves, leaving the green of the previous painting as part of the leaves.

8 I leave other touches of that original green visible because it enhances the composition. In other areas of the drape, I cover the previous color in black.

9 The glass jug is painted in a slightly darker value of the raw white used for the wall behind, but I add a blue-green tone that gives it a transparent effect.

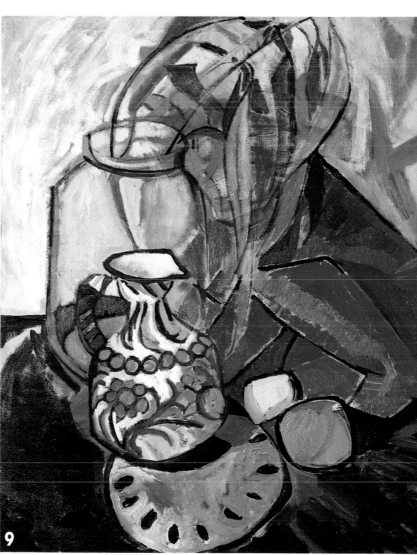

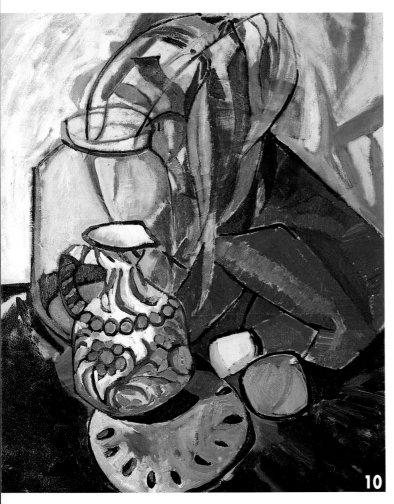

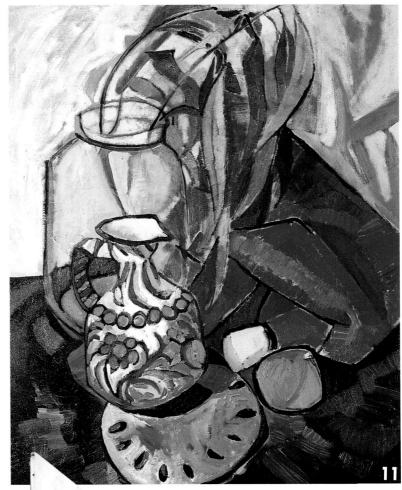

10 I paint the lemon and the orange making use of the green left from the previous painting to suggest a shadow. This was something of a daring challenge that often produces excellent results.

11 I add brushstrokes in a lighter value to emphasize the light on the left-hand side of the drape.

<div style="background-color:gray">

HOW TO RELAX AFTER AN ENORMOUS EFFORT

In general, I work standing up. After such an exhilarating and exhausting exercise like this one, it is essential to relax, which does not necessarily imply that you stop painting, only perhaps you work more slowly while seated. You should take advantage of this moment to resolve the smaller details and subtler tones.

</div>

12 This is the finished work. Lively colors, backgrounds, mixes, movements, connections, lights, darks, and shadows combined in an explosive display of brushstrokes. A perfect way of summarizing everything we have studied throughout the pages of this book.

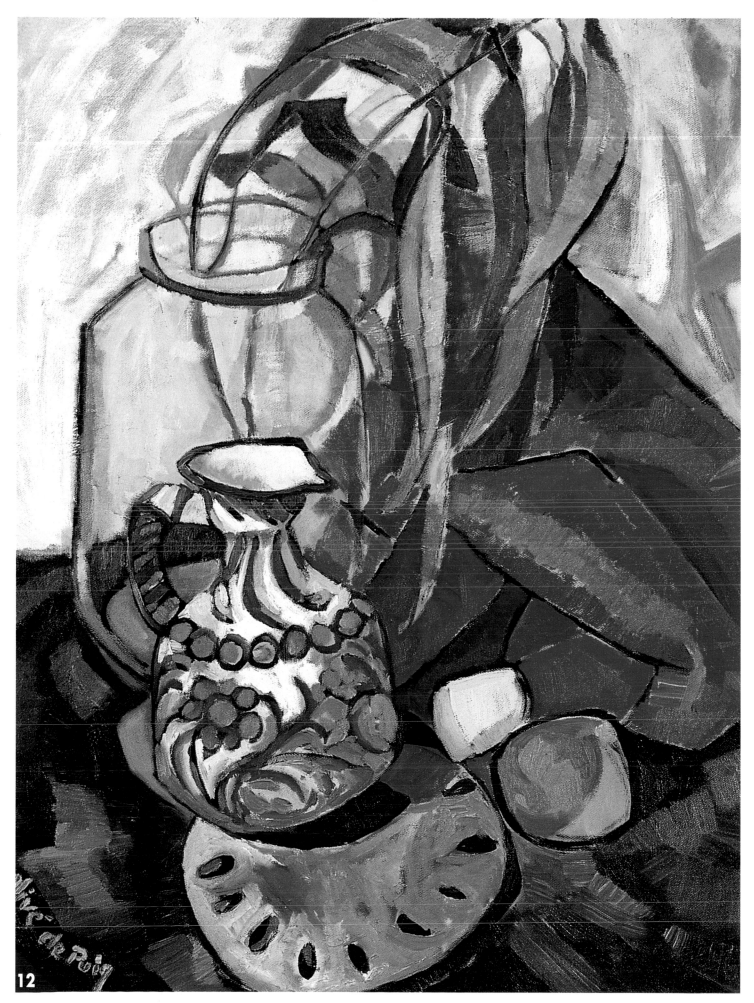

ACKNOWLEDGMENTS

I would like to express my sincere thanks to Muntsa Calbó for the opportunity to publish this book, since it was she who introduced me to the Parramón team.

Special gratitude must go to Jordi Vigué, who believed in me from the very start; throughout the development of this book, and even in the most difficult moments, he was always willing to come to my aid.

My thanks also to Juan Soto, an excellent photographer, who worked alongside me. In addition to the many unforgettable days spent together in the process of this book, I am grateful for everything he taught me.

I am extremely grateful to Josep Guasch for helping me out in some of the more important aspects of this book.

Esther Olivé de Puig